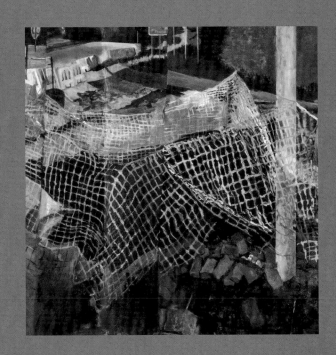

Between the

SHADOW
& the Light

An Exhibition Out of South Africa

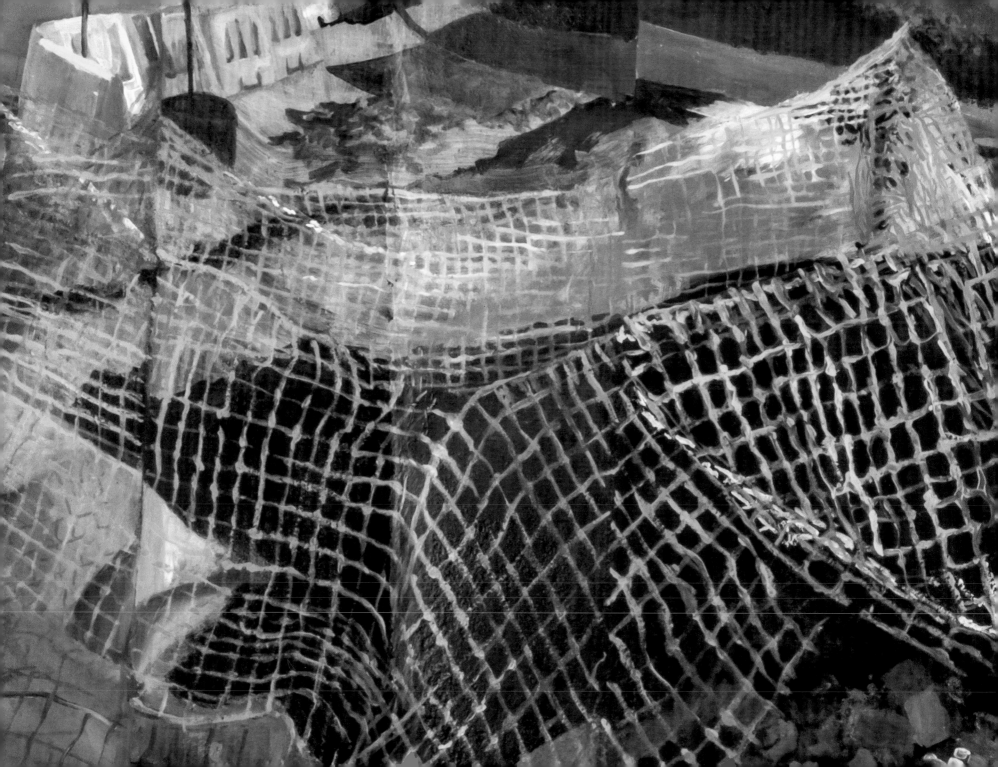

R5

Remembrance:

the intertwined and contested histories of varied people groups

"There is no clear light,
No clear shadow, in remembering..."

—Chilean poet Pablo Neruda in *There is No Clear Light*

"...sometimes you carry, and sometimes you are carried."

—Dumile Feni, South African sculptor (1942-1991),
referring to his sculpture *History*

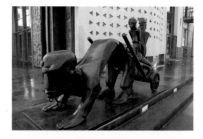

top down: Eternal Flame *at Freedom Park, Pretoria; Dumile Feni's
sculpture* History *at the entrance to the Constitutional Court,
Johannesburg; and memorial inscriptions at Freedom Park, Pretoria
far left: detail, Jo-Ann VanReeuwyk's* Tyre, *2013*

Between the
SHADOW
the
&*Light*

An Exhibition Out of South Africa

curated by Rachel Hostetter Smith
with the assistance of
Jo-Ann VanReeuwyk *and* Joel Zwart

cosponsored by
The Lilly Fellows Program for Humanities and the Arts
The Council for Christian Colleges and Universities
and The Nagel Institute of Calvin College

with major support from
Walter and Darlene Hansen
John and Mary Loeks
Doug and Lois Nagel
The Calvin Center for Christian Scholarship
The Joan L. and Robert C. Gilkison Family Foundation

dedicated to the memory of
H. Russel Botman
Rector and Vice-Chancellor, Stellenbosch University
born 18 October 1953, died 28 June 2014

CALVIN
Co l l e g e

Published by Calvin College

3201 Burton St. SE, Grand Rapids, Michigan
49546-4388
800-688-0122,
www.calvin.edu

EDITOR: Rachel Hostetter Smith

ART DIRECTOR: Rachel Hostetter Smith

PHOTOGRAPHY: John Corriveau
with additional images by Keith Barker, Larry
Thompson, and courtesy of the artists

DESIGN: Krista Krygsman

PRINTING: Holland Litho

ISBN 978-0-9727260-9-2

www.calvin.edu/nagel/r5/

The Nagel Institute is an agency of Calvin College that
sponsors research and other programs that promote
a deeper understanding of Christianity in the Global
South and East, foster Christian thought and cultural
engagement in those regions, and encourage a
reorientation in North America toward the concerns
of world Christianity.
www.calvin.edu/nagel

**Council for Christian
Colleges & Universities**®

The Council for Christian Colleges & Universities
(CCCU) is an international association of intentionally
Christ-centered colleges and universities based in
Washington, D.C. Founded in 1976 with 38 members,
the CCCU's mission is to advance the cause of
Christ-centered higher education and to help our
institutions transform lives by faithfully relating
scholarship and service to biblical truth.
www.cccu.org

The Lilly Fellows Program in Humanities and the Arts,
based at Valparaiso University, seeks to strengthen
the quality and shape the character of church-related
higher learning through a collaborative National
Network of Church-Related Colleges and Universities
along with a two-year postdoctoral teaching
fellowship at Valparaiso University and a three-year
graduate student fellowship for scholars to prepare
themselves for teaching and leadership within
church-related higher education.
www.lillyfellows.org

Contents

Between the Shadow & the Light Exhibition Schedule*

2014

Xavier University and the George and Leah McKenna Museum of African American Art
New Orleans, Louisiana
in conjunction with the Lilly Fellows Network Conference on Humanities and the Arts

2015

Calvin College, Center Art Gallery
Grand Rapids, Michigan
in conjunction with the Calvin Worship Symposium

Rivier University
Nashua, New Hampshire

Biola University
La Mirada, California

Judson University
Elgin, Illinois

2016

Bethel University
St. Paul, Minnesota
in cooperation with the University of St. Thomas

Asbury University
Wilmore, Kentucky

Whitworth University
Spokane, Washington

Mount Vernon Nazarene University
Mount Vernon, Ohio

2017

Hope College
Holland, Michigan

Samford University
Birmingham, Alabama

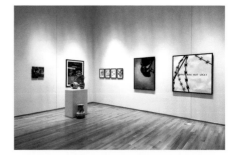

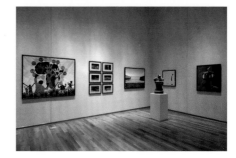

The exhibition will travel into 2018 in the United States. Some slots remain for bookings.
For more information contact: Rachel Smith, Curator and Project Director at rcsmith@taylor.edu .

*Venues confirmed as of publication of the catalog

Foreword

Joel A. Carpenter

This exhibit comes from a cross-cultural visual arts project held in South Africa in June, 2013. It engaged arts professors from American church-founded universities and a variety of artists—some teaching and others pursuing their art full time—from African nations: South Africa, Zimbabwe, Botswana, Nigeria, Ghana, and Kenya. The team spent two weeks together in and around Johannesburg and Cape Town. They engaged current realities in South Africa as they met with artists, activists, academics, and spiritual leaders. They engaged each other too, sharing their art and discussing what it meant to work as Christians and as artists. The group spent hours in studio together, experimenting with the ideas, images, and materials they had collected. Then they went home and produced the works you see in this collection.

The artistic leaders for this project were Rachel Smith, Gilkison Professor of Art History at Taylor University, who also is the curator and project director for this exhibit; and Charles Nkomo, a Zimbabwean artist living and working in Johannesburg who served as coordinator of the African artists. Just when Rachel and I were planning to launch this project we met Charles, who was exhibiting his work at Amazwi, a gallery for contemporary African art in Saugatuck, Michigan. Right off we sensed that Charles, who knew many artists in the region and had mentored some of them, was a godsend for this project, and indeed, so he has been.

Why did we want to do this project in South Africa? There is a remarkable visual arts renaissance taking place in that land, where recent history, lively religious dynamics and contemporary social challenges make a compelling setting for Christian artistic reflection and experimentation. In South Africa, said Okwui Enwezor, one of Africa's most eminent art critics, "art is not just an interpretation or facsimile of history, but a moral force in the production of a new reality, and hope for a damaged society."

As we studied the South African arts scene, we noticed that there were five critical issues with which South African artists struggle:

- Remembrance: the intertwined and contested histories of varied people groups.
- Resistance: the old, vivid, and continuing tradition of prophetic artistry.
- Reconciliation: persistent questions over how to justly reconcile aggrieved people.
- Representation: in a post-colonial, multicultural society, who may represent whom?
- Re-visioning: how does hope factor into artistic imagination?

So we called this project "R5," a name that evokes a common symbol in South Africa, the five-rand coin. It gave us a memorable rubric for these five critical issues. You will surely see these themes running through this collection.

Our group could have spent its whole time exploring the volatile social, economic, and political situation in South Africa. Yet with all the artistic energy at play in the nation, we could have spent the whole time encountering South African art and artists. And with all of the creativity in our group, we could have spent the whole time simply engaging each other.

Somehow, we managed to do all three. We visited the townships and churches, and we encountered historic sites too, such as the Voortrekker Monument and the Apartheid Museum. We visited several

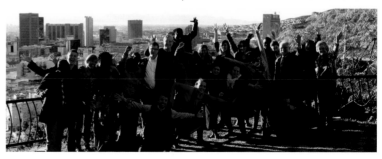

universities and important civic and governmental centers, most notably the Constitutional Court. And we were invited into the studios of leading artists, notably William Kentridge and Diane Victor. We heard from leaders in the historic struggle against apartheid and the process of national justice and reconciliation, such as Archbishop Desmond Tutu and Professor Piet Miering, who served with Tutu as the only Dutch Reformed minister on the Truth and Reconciliation Commission (TRC). We heard from veterans of the struggle against apartheid, such as the poet and journalist Zenzile Khoisan of Cape Town, who also led investigations for the TRC. And we heard from current activists in the struggle for justice and human flourishing, such as the Rev. Paul Verryn at the Central Methodist Mission in Johannesburg.

It has become common to observe that South Africa is a study in contrasts. That certainly proved to be true for us. We experienced holy joy at Regina Mundi Church in Soweto on a Sunday morning followed by crushing, grinding evil at the Apartheid Museum in the afternoon. One morning in Pretoria we saw the Voortrekker Monument, a massive granite tower that celebrates Afrikaners' divinely ordained destiny. But next was Freedom Park, a sunlit memorial garden to remember *all* who died in South Africa's struggles and wars. After a visit in the posh riverside town of Stellenbosch, we climbed up barren hillsides to visit Kayamandi, the adjoining township, where one member of our team lived.

Another morning we saw the Constitutional Court, where both the architecture and the art in its halls proclaim equal justice for all. But this was followed by a deeply disturbing visit to the Central Methodist Mission, an overworked shelter to some 1,000 homeless migrants, mostly from Zimbabwe. Then that evening we were hosted at the University of Johannesburg in its beautiful new art gallery for the opening of an exhibition, so we ended the day sipping wine and munching hors d'oeuvres with a gallery crowd—but imagining the great crowd of homeless folk bedding down at the Methodist mission. Our group certainly felt disrupted and jarred by what they were encountering. Yet they learned to "trust the process" of their learning, as they patiently sought from God and each other what Khoisan called "the exact way to walk between the shadow and the light."

Those words provided the title for this exhibit. The collection deals with the realities of suffering and injustice in the world today and the various issues that artists face in engaging these realities, as addressed by our R5 rubric. These works also evoke what we kept hearing over and over from our friends in South Africa—that what people and communities most need is hope, a quiet confidence in God's ways that will move them through and beyond their current situation. So our artists have explored aspects of hope as well as suffering and injustice. Their works encompass both concepts and concrete and practical realities, and they evoke spiritual concerns as well. They show the tension between two artistic roles—as both piercing prophets and hopeful seers.

We dedicate this exhibit to someone who embraced the tension between these two roles in his life and work, Professor H. Russel Botman, the black Reformed theologian who served as the rector of Stellenbosch University. Professor Botman was one of the piercing prophets of the Uniting Reformed Church who in the struggle against apartheid produced the Belhar Confession of 1982. Belhar declared that the integrity of the gospel was at stake in confronting the sin of racism. When our group of artists met with him at Stellenbosch, however, he spoke in the other vein, as a hopeful seer. His charge at Stellenbosch, he said, was to bring racial justice and reconciliation into the daily life of the university, which had once been the exclusive domain of whites. Professor Botman told us of the aims and progress of the university's "Hope Project," and of the vital role that the arts were playing in it. He encouraged us in our work, and then, a few months later, he agreed to give a major address at Calvin College when the exhibit arrived there. But we were not to see him again in this life: Professor Botman died suddenly in June, 2014. As

one of South Africa's wounded healers, Professor Botman gave his life for the rebirth of his society and to point his fellow citizens toward a greater glory, a city not made with human hands. So we honor him here and rededicate ourselves to what he saw so clearly.

H. Russel Botman and Joel Carpenter
during the R5 seminar, June 2013

facing page
Jonathan Anderson
detail, *Property Lines* 2013

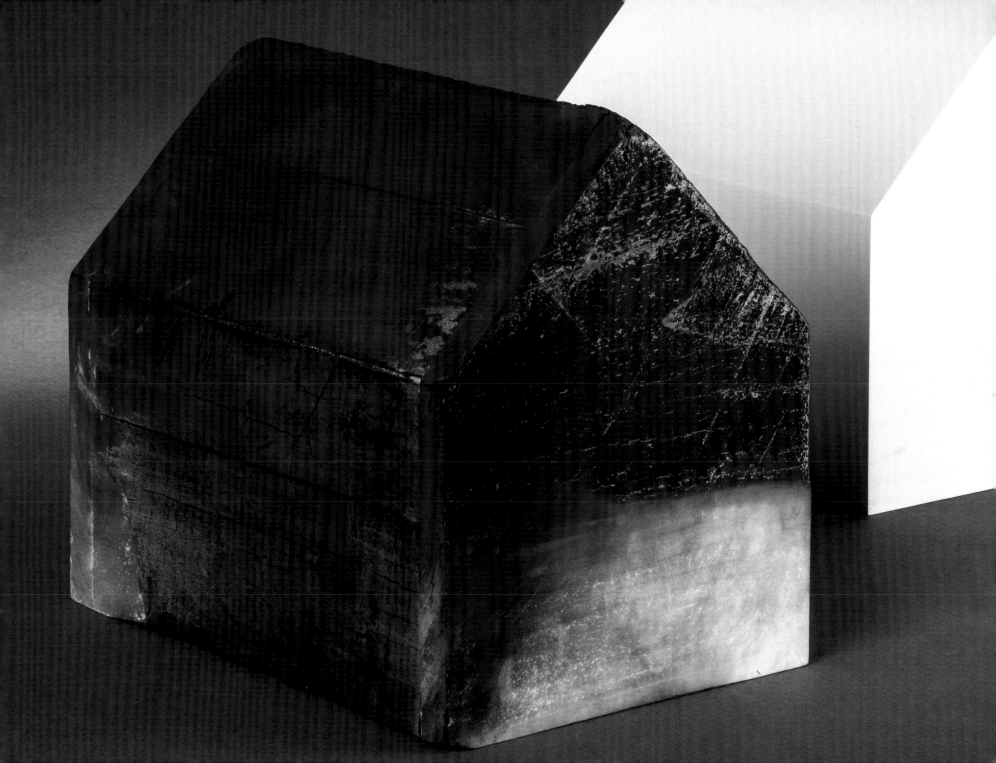

Resistance:

R5

the old, vivid, and continuing tradition of prophetic artistry

"Art is the absolute counterpoint to the unending assault on our common humanity."
—Zenzile Khoisan, poet and Chief Investigator, Truth and Reconciliation Commission

detail, Prison Hacks by Willem Boshoff (2003)
representing the 9,377 days Mandela was imprisoned,
Constitutional Court, Johannesburg

Essays —

"*Art is not just an interpretation or facsimile of history, but a moral force in the production of a new reality, and hope for a damaged society.*"

—Okwui Enwezor, African art critic

before the kindling of digital pages
before the press unbound the book
before scrolls were first revealed
in the beginning was the Word

and the Word was

 the heart of the Father
 the wisdom of the King
 the fire of the Holy Tongue
 and flesh on creation's bones

seated in the beginning with God
He said, 'let there be light'
and darkness was torched
'let there be life'
and skeletons stood up
'let there be love'

and the woman groaned
and the dragon groaned
and the temple tore her dress in two
while the feverish earth convulsed
as the pus of ages flooded in
to be swallowed up by forgiveness
captured by the great command

the Great Commander of Heaven's Armies
 God
who in the beginning was the Word

—Kambani Ramano

Of Nsenga and Venda parentage, Kambani Ramano is learning
what It means to be in the image of the Poet who crafted creation
with words. He lives in South Africa (used with permission)

Coloring the Wind
In and Out of South Africa

Rachel Hostetter Smith

In November of 2009, more than a year before I knew I would be traveling to South Africa for the first time, I was introduced to a piece of music that has since come to represent for me the hopes and aspirations of not only many South Africans but of peoples everywhere.

> *Khutso is a song that, like South Africa, gets under your skin and into your heart, haunting your thoughts and dreams.*

Khutso, Chant for Peace, is part of a collaboration between two choirs, I Fagiolini of Oxford, England and the SDASA Chorale of Soweto, South Africa.[1] In an enterprise similar to the R5 seminar that gave rise to the exhibition *Between the Shadow and the Light*, these two groups of musicians came together in April 1997 for "an intensive cultural exchange to compare, contrast and combine their respective musical worlds."[2] This experiment resulted in a remarkable body of music released under the title *Simunye*, a Zulu word meaning "we are one". *Khutso* is a song that, like South Africa, gets under your skin and into your heart, haunting your thoughts and dreams. It weaves together two varied musical traditions—an African chant sung in Sotho and the Gregorian *Agnus Dei* from the Latin mass—

to form a single poignant sorrowful plea for peace on *earth* as it is in heaven.

As *Simunye* project organizer Brett Pyper explains, "Oxford is a long way from Soweto, and the distance is not only to be measured in miles. Depending on from where you are looking, the two cities represent a lot of what is both best and worst about modern history. *Simunye* is a way of hearing that distance that draws on the spiritual traditions of both places and captures hints and echoes of a harmonious world."[3]

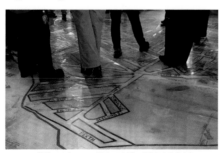

R5 seminar artists at the District 6 Museum

In June of 2013 artists and educators from the United States and six different African countries—Botswana, Ghana, Kenya, Nigeria, South Africa, and Zimbabwe—gathered in South Africa for two weeks of living, learning, and creating together. They undertook an intensive program of engagement with South Africa—its history, culture, and contemporary reality—and with each other through project R5: A Visual Arts Studio and Seminar in South Africa. As described elsewhere in this volume, R5 refers to five themes South African artists deal with in significant measure:

- Remembrance: the intertwined and contested histories of varied people groups.
- Resistance: the old, vivid, and continuing tradition of prophetic artistry.
- Reconciliation: persistent questions over how to justly reconcile aggrieved people.

- Representation: in a post-colonial, multicultural society, who may represent whom?
- Re-visioning: how does hope factor into artistic imagination?

But the intention of the seminar was not just to learn about South Africa but to learn *from* her. We recognized that the issues raised by the experience of South Africa have application everywhere and that South African artists could signal fresh ways that artists elsewhere might address the complexities of both our present reality and our future hope more effectively. So this cadre of artists committed to produce works of art in response to their shared experience in South Africa. This exhibition is the result.

While in South Africa together, we met with countless individuals who introduced us to a host of enterprises and endeavors—from the artistic to the practical, dealing with both material realities and spiritual truths. They shared their experience and expertise with us, reflecting a passionate commitment to address the needs of their country and her people in an effort to respond to an unspeakably painful and destructive history by working to make manifest a vision of a new—and different—society, a society in keeping with Mandela's vision of the "Rainbow Nation." But perhaps the most significant thing they shared with us was their selves. Talking openly about their own stories—their sorrows and joys, their struggles and aspirations, their hopes and dreams. Their stories guided our thoughts and conversations, imprinting themselves on our consciousness. Their words are sprinkled liberally among these pages encapsulating key

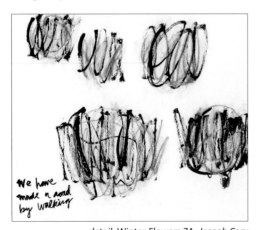

detail, Winter Flowers ZA, *Joseph Cory*

observations, adding flavor that enhances engagement with the artworks and the ideas embodied there, as salt and savor.

Our time with Zenzile Khoisan, poet and Chief Investigator of South Africa's Truth and Reconciliation Commission (TRC), in the crypt of St. George's Cathedral in downtown Cape Town was especially significant, informing our thinking—and this exhibit—in a special way. While our meeting was ostensibly to learn more about the work of the TRC, it was Khoisan's poetic zeal in describing the relationship between art and the pursuit of a more just world that directed our understanding of how artists might serve as both prophets—as harbingers of change—*and* seers by providing a vision of the world transformed that is being brought into being little by little. He told us that artists are given "the exact way to walk between the shadow and the light." As we grappled with the complexities of South Africa, where the good and the bad continue to be engaged in palpable struggle, this phrase came to represent the challenge we all face. Both as individuals and nations, no matter where we might live, we struggle to find a course that will bring about a more just and harmonious world. There are many contrasts and correspondences between what we found in South Africa and the other countries the R5 artists call "home." Many, significantly, were born and raised in one country and now live and work in another.

We recognized that the issues raised by the experience of South Africa have application everywhere and that South African artists could signal fresh ways that artists elsewhere might address the complexities of both our present reality and our future hope more effectively.

The Movement of Peoples

Disputed territories, contested histories, aggrieved peoples, *unsettled ground*. Human history has, through the ages, been shaped and directed by the movement of people—individual and corporate— variously seeking fertile ground, a better life, a fresh start. These

migrations have fueled the world's development in a manner that binds it together in vital and productive ways. But these same migrations have also introduced fault lines where differing ways of life, traditions, and aspirations

threaten to split them apart and with violent effect. Instead of coming together as one happy global human family the peoples of the world persist in setting themselves against one another, at times with good and righteous cause but nearly always to devastating effect. We have only to listen to the news to witness the evidence of this reality around the world—in Ukraine, in Congo, in Afghanistan, in Venezuela, among the Uighur and Tibetan minorities in China, and even in what we assume to be settled nations such as Spain and Canada where independence movements of the Catalan, Basque, and Québécois people continue to gain strength. Many of us cultivate a false sense of security. As is the case for those who live along geological fault lines, we suppose that all is well, that we reside on solid ground only to discover that fault lines exist beneath our very feet and that the neighborhood where we live is anything but settled.

Correspondences between aspects of South African and American history surprised many of the North American artists, all of whom are descendants of immigrants from Europe who came to the so-called "New World" in search of opportunity they did not have in the "Old," much as the South Africans of European descent did. Confronting the realities of South African history required them to consider the truth that there was much to deal with in their own country's past. The similarity was startling at times. The imagery at the Voortrekker Monument in Pretoria might have depicted American pioneers—men, women, and children of European descent dressed in 19th century garb with all of their worldly goods packed into covered wagons, on an arduous journey in search of land and a life that they would build together in that new country. Instead, the monument depicts the Dutch Boers (Dutch and Afrikaans for "farmers") who were on their "Great Trek" in the 1830s deep into the heartland of what would eventually

become South Africa in search of land and freedom from British rule. But it also brought them into violent clashes with the Zulus there. In each country, the stories involve interactions—some peaceful, many not—which ultimately brought about the displacement, forced removals and subjugation of the native peoples. These similarities emerge regularly in Michelle Westmark-Wingard and Magel van Rooyen's visual correspondence *From My Side of the World*; for example, when Michelle visited the Minnesota State Fair and saw a statue remarkably similar to one at the Voortrekker Monument in Pretoria. The complex realities involved in the movement of peoples around the world and across history came home for both artists as Michelle marked Columbus Day in the U.S. by observing that it is, "...a day that is complex. It was the discovery of an already inhabited new world." Magdel's response: "Loss and destruction, progress and prosperity."

It is a commonplace to observe that "history is written by the victors." But it is equally true that opposing parties involved in a particular exchange will understand and remember it differently. *Trespassers on Our Own Land* by Joseph Cory presents a disturbing image of the truth that, while the European settlers saw much of the land—in South Africa *and* in North America— as "uninhabited" because there weren't permanent homesteads or villages there, the native peoples, who were nomadic, claimed them as periodic hunting and grazing lands, essential to their way of life. Over time, the native peoples came to be treated as "trespassers" by the settlers, in perception and, eventually, by law, on land that the native peoples saw as theirs. Clashes resulting from different patterns of land use and ownership can be found in virtually every quarter of the world and is the frequent cause of tensions and violence among different people groups.

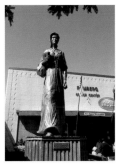

But the movement of peoples also may bring unanticipated

left: Allen Sibanda taking a photo at the Voortrekker Monument, Pretoria; right: Michelle Westmark-Wingard's photo from the Minnesota State Fair, From My Side of the World

detail, Beached: Borne, *Katie Creyts*

challenges for those who migrate, as we well understand from the experience of current immigrants. Katie Creyts' work titled *Beached* is composed of five panels depicting whales in various states of dislocation and distress. It is a meditation on what it means to move out of one's element using the metaphor of migratory whales. Seeking new feeding grounds, they may find themselves beached and in danger for their lives. The juxtaposition of rough textures and somber colors with elegant incised patterns based on Dutch Delft-ware *in glass*, a medium typically used for objects of delicate beauty, is startling. The whales "drooling gold," as Katie puts it, are a powerful reminder that fighting for survival in what is perceived to be a hostile environment often brings out the worst in us. Greed can overtake us. *Beached* is a melancholy lament, calling attention to both the state of the whales and the impact—on others and their selves— of their arrival in an alien place. Inspired by the encounter with South African history, the work is, however, more fundamentally, commenting on the human condition.

The Struggle in South Africa

Another issue that came to the fore in many of the artist's contributions to the exhibit was the need to remember the past and to properly acknowledge the extent of the indignities and many atrocities exacted on individual lives, communities and whole people groups.

South African art is replete with powerful examples of works of art commemorating the long history of the resistance or "struggle" as it is commonly called.

Valentine Mettle describes his triptych *From Struggle to*

detail, Reflections, *Charles Nkomo*

Victory as "a tribute to South Africans' struggle for 350 years to gain equality and justice." He depicts three successive stages in the process: *Resistance, Petition,* and *Release*. Using mixed media of fabric and cord glued to painted canvas, these works have a graphic force. Significantly, Valentine depicts not just the country of South Africa, but the continent of Africa. In *Resistance* the dark silhouette of Africa is surrounded by a circle of hands in the colors of the rainbow with a fist clenched in the gesture for solidarity. In *Release* hands in many different colors thrust up from the south of the continent while people dance in jubilant celebration in the foreground. South Africa's struggle is, in many respects, representative of a larger struggle for the continent as a whole. Initially a fight for freedom from colonial rule, it continues as people in many nations across Africa struggle against corrupt, oppressive, and often violent powers. As a Nigerian who because of conflicts there, left his home country to settle in South Africa, Valentine understands this well. Notably, in the center-piece of the triptych, *Petition*, people raise their hands to the cross reflecting the importance of faith in the midst of hardship and difficulty in Africa and the world over.

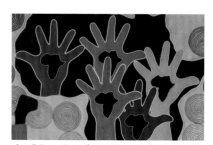

detail, From Struggle to Victory, *Valentine Mettle*

Many of the artworks recall specific events or actualities. Charles Nkomo's painting titled *Reflections* is a response to the forced removals of the residents of District 6, only one of many such communities that were displaced for political or economic purposes. One can just barely glimpse the roof-lines of homes through a kaleidoscope of vibrant color that is commonly seen in both the multi-cultural neighborhoods of Cape Town and the shacks of the out-lying townships to which people were relegated. It is testimony to their resilience and will to make the most of what little they had. Yet despite the repeal of apartheid more than twenty years ago and a democratically elected government that reflects majority rule, as Charles notes, "The black majority is still living in abject poverty

and the political leadership is getting wealthier as a result of corrupt tendencies." Ironically, District 6 manifested what Nelson Mandela envisioned for South Africa as a whole—a truly multi-cultural, multi-racial society—before it was razed in the 1970s.

South Africa's struggle is, in many respects, representative of a larger struggle for the continent as a whole. Initially a struggle for freedom from colonial rule, it continues as people in many nations across Africa struggle against corrupt, oppressive, and often violent powers.

South African Xolile Mazibuko's painting *A Woman's Day in South Africa* examines a different, yet related aspect of apartheid: identity papers and passbooks. South Africans of color were required to carry them at all times to control the movement of individual persons based on racial designation. The painting pictures several different versions of identity documents, two of Xolile's own and another belonging to a white woman of about the same age. Changing criteria for these designations could result in the same person gaining or losing freedoms from one day to the next. In the worst cases, such changes required married couples or parents and children to separate because one party's new racial designation no longer permitted cohabitation. The painting is all the more powerful for the flames consuming the passbooks with the specter of marching figures in the background calling to mind a long-standing form of resistance to the pass laws and apartheid, the burning of the passbooks. One particularly tragic example is the widespread burning that led to the Sharpeville Massacre.

The Hole Truth by Phumlani Mtabe also draws on a specific event in the struggle movement for its subject: the Soweto Uprising on 16 June 1976 when the youth of Soweto protested against their schooling in Afrikaans. It was a requirement that provided yet another instrument of control and limitation over the educational success and subsequent opportunities open to those youth. An estimated 20,000 young

people came out to demonstrate. The day ended in a violent conflict with police resulting in many deaths. Photographs of the slaughter of children as young as thirteen served as a wake-up call to South Africans of every color marking the beginning of the end of the struggle. Phumlani's small cardboard coffin pierced by barbed wire is a poignant reminder of the brutality of the system, the many innocent lives lost, and the will of the people to undo it. As the pressure to repeal apartheid intensified through the 1970s and 1980s violence escalated. Production of coffins in the townships stepped up so that the sight of stacks of empty coffins ready for use was common. Funerals became virtually everyday events as the conflict ensued. They were occasions not only for honoring the memory of the deceased but fostering the solidarity of the people to the cause. Through a small hole in the lid of the coffin one can see the words "Holy Peace," "The Hole Truth". It is a charge to acknowledge the dark reality of this time and the need to uncover the *whole* truth.

detail, The Hole Truth, *Phumlani Mtabe*

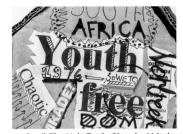

detail, A Woman's Day in South Africa, *Xolile Mazibuko*

Jo-Ann Van Reeuwyk's mixed media fiber work titled *Tyre* (tire) is a response to yet another horrific practice that developed during the 1980s at the height of the violent conflict that preceded the repeal of apartheid: "necklacing". Sadly, it was a practice exacted almost exclusively by black South Africans against other blacks. According to Lynda Schuster, "'Necklacing' represented the worst of the excesses committed in the name of the uprising. [It] was a particularly gruesome form of mob justice, reserved for those thought to be government collaborators, informers and black

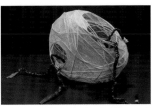

Tyre, *Jo-Ann VanReeuwyk*

policemen. The executioners would force a car tire over the head and around the arms of the suspect, drench it in petrol, and set it alight. Immobilized, the victim burned to death."[4] It was an agonizing death, taking twenty minutes or more before the victim succumbed to the fire. In a famous incident in 1985, Archbishop Desmond Tutu intervened to prevent one such execution, calling for a stop to the practice, saying that it hurt the cause. The sinister nature of necklacing is seen in the disturbing creature-liness of *Tyre*. It is headless, apparently alive and menacing without evident purpose or cause. Because of the history of necklacing in South Africa, the tire has become an ominous symbol of torture and treachery employed by many artists. As Jo-Ann observes, the term itself calls to mind the great irony of Christ's crown of thorns, a dual sign of undeserved torment *and* sovereignty.

> *It is a commonplace to observe that "history is written by the victors." But it is equally true that opposing parties involved in a particular exchange will understand and remember it differently.*

Bearing Witness

In an article in *First Things* titled "What Art Can—and Can't—Do", Philip Yancey describes, using a metaphor from animal husbandry, the ways in which art can serve as a goad, an instrument that "creates [just] enough discomfort" to cause animals—or people, in this case— "to do something they otherwise might not do."[5] He contrasts this with art that might serve as a "firmly embedded nail." Whereas "a goad prods to immediate action,…a firmly embedded nail settles deeper, as an indelible marker of what T. S. Eliot called 'the permanent things.'"[6] Many of the works just described are like goads prompting remembrance so that such things are not repeated.

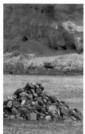

left: Robben Island Quarry Stone Pile
right: detail, Memorial, *Jonathan Anderson*

Jonathan Anderson's *Memorial* takes its inspiration from a commemorative monument, a stone pile in the lime quarry where Mandela and other prisoners worked on Robben Island each day. It was erected by a gathering of former political prisoners and friends to honor Mandela's release from prison after twenty-seven years behind bars. But as former Robben Island political prisoner Lionel Davis says, "We can't build South Africa on bitterness. The idea of reconciliation would not have been a reality if Mandela had not made it a reality," said Davis. "It is up to us to continue to make that legacy a reality."[7] Using stones brought back to the U.S. from South Africa, Anderson has piled them in the center of a tattered European lace tablecloth, juxtaposing two reminders of the history of that place and its peoples. Rubble or stones appear in a number of other works in the exhibition. The Old Testament is full of instances where people composed piles of stones as a sign of remembrance of a site of adversity or a reminder of God's

detail, Man in the News, *Petros Mwenga*

presence along life's journey. It is a practice shared by many different cultures. For Jo-Ann VanReeuwyk, stones have become synonymous with forgiveness since reading *The Book of Forgiving* (2014) by Desmond Tutu and his daughter Mpho. Carrying a small stone in her pocket reminds her to be faithful to the example of forgiveness of South Africans like Mandela, Davis and Tutu.

Nelson Mandela's given Xhosa name was *Rolihlahla*, "one who pulls the branches of a tree" or, colloquially, "trouble-maker," a fitting name for the boy who would play such a profound role in South Africa's resistance movement. But it is Mandela's response to his release after twenty-seven years of imprisonment that is the most remarkable— calling for forgiveness, championing a vision of a new South Africa that belonged to all people regardless of color and drafting a constitution that is seen as one of the most progressive in protecting the rights of all people. Perhaps most significantly, however, is his institution

Truth and Reconciliation Commission which provided a pathway to a measure of healing for many individuals and the nation. In explanation of this strategy, Mandela said, "the spirit told me, 'do not be a prisoner now that you have been set free,'" bound by anger, resentment and desire for retribution. It is a model for every one of us.

As Zimbabwean artist Petros Mwenga shows in his work *Man in the News*, Mandela was a man who "changed history" in more ways than one. The profound outpouring of grief around the world following his death on 5 December 2013 is testimony to the impact of not only his actions, which brought about the end of apartheid in South Africa, but also of his person in the way that he lived and governed after he was elected the first president of a free South Africa. As Petros notes, in contrast with so many heads of state in Africa, Mandela stepped down of his own accord instead of wresting power for himself to the detriment of the people and his country, allowing democracy a chance to take root and grow stronger.

While *Man in the News* and *Memorial* reflect on the legacy of a well-known giant like Mandela, Joseph Cory's painting *The Unnamed Few (After Judith Mason)* pays homage to those whose names are less known but who, nevertheless, suffered unimaginable degradation and also death under apartheid. A small abstract dominated by a lush aqua blue, the painting was inspired by the story behind a work of art by South African artist Judith Mason titled *The Man who Sang and the Woman who kept Silent* (more commonly known as *The Blue Dress*) that he saw in the Constitutional Court in Johannesburg. Mason's work was inspired by the story of a woman she heard on the radio during the hearings of the TRC, "...Phila Ndwande, 'who was tortured and kept naked for ten days' and then assassinated in a kneeling position. As Mason recounts, before Ndwande was killed, she 'fashioned a pair of panties for herself out of a scrap of blue plastic.' Ndwande's body was found naked in a shallow grave, with the thin piece of plastic still covering her private parts. Mason was so moved by her tragic story

Judith Mason, The Man who Sang and the Woman who kept Silent *(Triptych), 1998 oil on canvas, 48" x 65 ⅛", sculpture (dress), 27 ½" x 78 ¾" x 17 ⅔", oil on canvas 63" x 74 ⅛" Collection: The Constitutional Court, South Africa; permission of the artist © Judith Mason*

that she made a dress of blue plastic bags on which she inscribed a text [that began], 'Sister, a plastic bag may not be the whole armour of God, but you were wrestling with flesh and blood, and against powers, against the rulers of darkness, against spiritual wickedness in sordid places. Your weapons were your silence and a piece of rubbish.... *Hamba kahle*...[Rest well].'"[8] This story and Mason's "blue dress" have come to represent—for South Africans and all who know it—the inherent dignity of human being and the drive to preserve that dignity in the midst of unimaginable degradation even unto death. It is the story of countless individuals—men, women, and children of every age, color, and creed—who suffer in like ways all over the world.

Jackie Karuti of Kenya took up the story of one who began on the other side of South Africa's conflict, the supporters of apartheid. Her painting *Stefaans' Letters* was inspired by the real experience of a young Afrikaner named Stefaans Coetzee who was convicted of a series of bombings in 1996 along with a couple of friends in the years immediately following the end of apartheid and the establishment of a free and democratic South Africa. Jackie's painting reflects this young man's change of heart and mind following his conversion to Christianity behind bars for his crimes. It reveals the anguish he experienced as he came to see what he had really done. It is an outcry in searing oranges and bruised reds, its drips and lines of paint giving

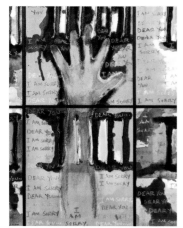

detail, Stefaans' Letters, *Jackie Karuti*

tangible expression to the agony of a person who has repented and desires to make some small gesture, however inadequate, toward restitution for his sins. It is a picture of a man who longs for forgiveness from those he has harmed. As Jackie observes, in the "two weeks we spent in South Africa, I came to understand the power of forgiveness, especially based on the impact the Truth and Reconciliation Commission had."

Hybrid Cultures and the Question of Identity

Like many countries contemporary South Africa is composed of a multiplicity of ethnic and racial groups that came to be there for widely differing reasons. Soon after the Dutch established the Cape Colony in 1652, the first slaves and indentured servants arrived from East Africa, Madagascar, and the East Indies. Some of them were brought to the Cape by the Dutch from their outposts in Malaysia giving rise to the "Cape Malay" subculture of present-day Cape Town. They have called the region home for well over three hundred years. Laborers and traders from India came largely as indentured servants in response to the booming growth that was spurred by the discovery of gold and diamonds in the latter 19th and early 20th centuries. Many of them stayed. Mahatma Ghandi 's presence in South Africa can be attributed to the opportunity that drew people from various parts of the world there during that period. The small but noteworthy Jewish minority in South Africa can be traced to waves of immigration by Jews fleeing Russia to escape the brutal pogroms of the late 19th and early 20th centuries, and as European Jews fled Europe in the face of rising Nazi power throughout World War II. These peoples joined the African Bantu peoples and Dutch and British settler populations. As

people mixed and, in some cases, married, a complex web of vibrant cultures came into being giving rise to new possibilities *and* tensions.

Chronicle I; My Traitor's Heart, a painting by Katherine Sullivan, presents the interaction of these diverse people groups and their respective cultures. The dominant brown form refers to the indigenous African peoples, the garland of marigolds the Indian population, and the blue and white fabric printed with springbok (a species of antelope native to the region and now the national animal of South Africa) represents the Dutch who increasingly embraced Africa as "home." Interestingly, the Dutch are responsible for the mixing

> *...in the "two weeks we spent in South Africa, I came to understand the power of forgiveness, especially based on the impact the Truth and Reconciliation Commission had."*

of many aspects of culture as they made their way around the globe, bringing, as we see here, batik printing techniques from Malaysia to Africa as they moved into the continent. The forceful forms in this painting exude ominous power while the lushly painted surfaces seduce with color and texture in carefully constructed relationship.

There are many instances of cultural cross-pollination beyond fabric design. South African musical styles often draw on a variety of cultural sources to create rich new forms. One example is *isicathamiya*, which means "to walk stealthily like a cat." It combines aspects of traditional African dance and music with close four-part harmony derived from the Bach choral tradition brought to South Africa by European settlers and missionaries. There is perhaps no better example of this hybridity than the language Afrikaans which originated as a "kitchen language" that developed as the Dutch settlers lived and worked with African and Indonesian workers and slaves on their farms. It is a mix of Dutch, Koi Koi, Indonesian, and French that was only

detail, Chronicle I; My Traitor's Heart, *Katherine Sullivan*

codified as a written language after 1948 when the National Party came to power. For Afrikaners South Africa is home. Many of their families have been in South Africa for over three hundred years. As Johan Horn, Executive Head of the African Leadership Institute for Community Transformation (ALICT) explained, recalling his ancestors' arrival in South Africa in 1652, "I have no other motherland. I am probably more African than you are American [speaking to the North Americans]."

The migration of peoples, interaction and influence among cultural groups, and mixed heritage complicate the formation of identity for many people effecting how they see themselves, especially in relation to their society. Deléne Human's *Hunger Belts* explores issues of identity and aspiration drawing on a variety of cultural sources including the traditional African beading, patterns and coloration for figurative objects known as "child dolls" (previously called "fertility dolls"). They are not dolls at all, in the sense that they were not intended for play, but small figural objects women kept from childhood through adulthood as repositories of their hopes and dreams. Deléne creates her own contemporary version using a seamstress's form covered with belts that belonged to female friends, family members, or her to embody her hopes and dreams as a young Afrikaans-speaking woman in the new South Africa.

> *There is perhaps no better example of this hybridity than the language Afrikaans which originated as a "kitchen language" that developed as the Dutch settlers lived and worked with African and Indonesian workers and slaves on their farms. It is a mix of Dutch, Koi Koi, Indonesian, and French...*

INHABIT: shantytown, a collaboration among three of the artists, Margaret Allotey-Pappoe of Ghana, Deléne Human of South Africa, and Jo-Ann VanReeuwyk of Canada explores some of these same issues. Significantly, each of these women bears a hybrid identity. Born and raised in Ghana, Margaret did her graduate work in the United States where she now resides with her husband and children. Deléne is a woman of European descent

 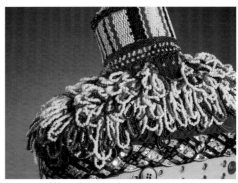

details, Hunger Belts, *Deléne Human*

whose family has lived in South Africa for generations but carries the distinct burden of being a member of the minority associated with the apartheid policies of the past. Jo-Ann is Canadian born and bred, but has lived and worked much of her adult life in the United States. *INHABIT: shantytown* is composed of three vessels, one made by each woman to reveal something of how she sees herself particularly in relation to her "habitat." Each vessel, decidedly unique like the woman it represents (photos next page), reflects this complex mélange that is increasingly the norm in this shrinking world we now inhabit. The designation "shantytown" implies the hodge-podge constructions, like the improvised shacks found in South African townships and so-called "squatter" communities outside of cities in so many countries, created as temporary places to stay on one's way somewhere else. When the temporary becomes permanent, however, as it so often does, it requires a new and different definition for home.

Ties that Bind: The Fabric of Our Being is an installation of video stills of a performance work by Keatlaretse (Kate) Kwati of Botswana. While the performance reflected some aspects of an African context, Kate

explains that she believes that "women's issues are universal. We experience similar psychological and physical wounds, scars, pain, wishes, and emotion." The actions of binding and cutting, sewing and snipping are metaphorical. The ropes represent things that might ensnare them, limiting and harming them. But they can also represent those things to which they are bound that nourish and help them to flourish. The challenge is discerning which is which and having the courage to take action to become the persons they could be.

details, INHABIT: shantytown,
Margaret Allotey-Pappoe,
Deléne Human,
Jo-Ann VanReeuwyk

In *An Intentional Intersection* American Larry Thompson investigates the relationships among our individuality, racial and cultural distinctness, and our common humanity. Alternating fragments of his face with that of his R5 seminar roommate, Nigerian Valentine Mettle, he presents us with an arresting vision of what Jeremy Begbie calls "enriching difference." Using the example of music, Begbie demonstrates how two very different musical voices, instruments, or styles can come together to create an aural resonance such that it allows each part to remain distinct even as it enhances the unique qualities of the other.[9] *An Intentional Intersection* achieves a corresponding result through visual imagery. The block letters spelling out the phrase "WE'RE THE SAME TRIBE" only serves to assert more forcefully this vision of unity in diversity for which we are made and long despite how elusive it remains to achieve.

"Things are Not Okay"

The reality is that it takes a very long time for individuals and societies to heal from the

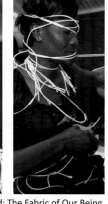

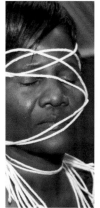

details, Ties that Bind: The Fabric of Our Being,
Keatlaretse Kate Kwati

wounds of the past. Allen Sibanda addresses this in his works *I know a place (still mending)* and *Scars will always remain*. Like Kate Kwati in *Ties that Bind: The Fabric of Our Being*, Allen utilizes sewing as medium and metaphor to convey these concepts. Silhouette and transparence capture the complex relation between what is seen and what is hidden, the external visage and the interior self. Father Michael Lapsley, founder of the

detail, An Intentional Intersection,
Larry Thompson

Institute for Healing of Memories in Cape Town, has explained "that whatever happens to us in life, it will cause us to diminish or to grow. So it is important for individuals, communities and nations to fund life-giving responses to the trauma which they have experienced."[10] More specifically, it is important for people to find ways to acknowledge *and let go* "of that which is destructive inside them...taking from the past that which is life-giving."[11]

Joseph Cory's painting *All That Lies Behind Us* reminds us that memory is both a powerful and slippery thing. Taking its title from a line in Chilean poet Pablo Neruda's poem about memory, *There is No Clear Light*, the ghostly figures emerging as if from a fog perfectly show the way that the past, or our memories of the past to be more precise, haunt us if we don't deal with them. Keith Barker of the North American team experienced this first-hand when he decided to engage a part of his family's history related to South Africa. Never having set foot in South Africa before the

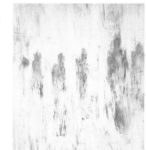

detail, All That Lies Behind Us,
Joseph Cory

R5 seminar, Keith decided to visit the gravesite of his mother's father—a grandfather he never knew—a missionary who was attacked and killed one evening on his way home from a meeting

in Johannesburg in 1961. The perpetrators were never identified. Nevertheless, this loss was reclaimed in some small measure through that visit and by the making of his video *Commemoration*. His account can be read in the moving essay in his book of photographs of South Africa titled *Somewhere Else*. These works—and Keith's experience—demonstrate how things past that may seem irrelevant to our present often shape us and our perceptions.

Despite the tremendous advances South Africa has made toward achieving Nelson Mandela's vision of a rainbow nation—a remarkable constitution, a level of healing for some individuals and society, open elections, freedom of movement and economic opportunities that did not exist for the majority only a couple of decades ago—problems remain and new challenges threaten the health of the democracy and the well-being of the people and the state. Limited educational resources for a growing population, the devastation of a whole generation and certain populations by the HIV/AIDS epidemic, unemployment estimated at between 30 and 50 percent, and corruption undermine the efficacy of nearly every aspect of society and government. As Johan Horn, Executive Head of ALICT told us, "Things are not okay." Larry Thompson's provocative painting *Barriers Still* has Johan's words emblazoned on a bright blue sky, as arcs of razor wire slice across it, destroying the apparent tranquility. It proffers both protection and threat, a barrier designed "to keep something in *and* keep something out" as Larry explains. We saw it everywhere we went. Johan was right. Things are not okay in South Africa.

But as our time together progressed, members of the African team from countries other than South Africa

Never having set foot in South Africa before the R5 seminar, Keith decided to visit the gravesite of his mother's father—a grandfather he never knew—a missionary who was attacked and killed one evening on his way home from a meeting in Johannesburg in 1961.

observed that while they were very disturbed by the realities of apartheid and its effects, their countries and people did not have some of the advantages and opportunities that South Africans had living in the

detail, Commemoration, *Keith Barker*

Somewhere Else, *Keith Barker*

most developed and economically prosperous country on the continent. It should be no surprise that South Africa is experiencing a flood of immigrants from all over Africa who are fleeing violence, political persecution and poverty to compete for jobs and services against South Africans who need them, too. "It's complicated," we kept hearing. Testimonies about the realities of political oppression in places like Zimbabwe and Nigeria, and the dirth of educational and economic opportunity as well as political corruption and violence elsewhere in Africa revealed that things are not okay in those countries either. South Africa simply provided a mirror for seeing the problems in one's own country more clearly. And each of these realizations caused us to recognize, individually and corporately, this fundamental truth: that things are not okay—anywhere—not even in the United States (where we have our own complex and painful history and rising problems to address), *nowhere.*

So what might artists do? In South Africa, said one of Africa's most eminent art critics, Okwui Enwezor, "art is not just an interpretation or facsimile of history, but a moral force in the production of a new reality, and

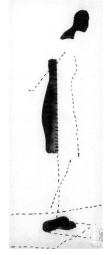

detail, I know a place (still mending), *Allen Sibanda*

THINGS ARE NOT OKAY

detail, Barriers Still, *Larry Thompson*

hope for a damaged society." It is a place where artists continue to act both as piercing prophets and hopeful seers. One such artist is Diane Victor, a leading South African artist with an international reputation. Her work leaves an indelible mark on all who see it. Among the great variety of social themes on Victor's mind and in her art are the devastation of the AIDS virus on individuals and their communities, violence against women which has reached the highest rates in the world for a nation that is not at war, and the impending extinction of the rhino which are being killed in order to harvest their horns, for selfish or desperate economic benefit. Her art, Victor says, is her way of dealing with the anger she feels at the violence and social injustice she witnesses daily.

Victor's work gains much of its impact from the very techniques she employs like drafting the faces of those who have succumbed to AIDS or unspeakable violence using the smoke wafting from a lit candle. One false move might send her subject up in flames. On occasion, she uses ash from the books that informed her subjects' lives to draw their likenesses. Through these forms and media she reveals the preciousness and fragility of each person rendered and does so with such an apparently soft touch that it infuses her images with an almost sacramental power. Her work may be fueled by anger, but it is equally clear that it is motivated by love and a will for things to be different. Nevertheless, Victor is but one of many artists whose work serves as "a moral force in the production of a new reality" providing "hope for a damaged society."

Opening one's eyes that we might see what is really in front of us is a start, as Jonathan Anderson's *Apocalypse* suggests. But trying to understand the experience of others is the greater challenge as he shows in his painting *Cape Town, ZA/Long Beach, CA* since our own lives are real

and close at hand and the other seems so distant and far off. Recognizing that there are many experiences we hold in common with people across time and around the world will help us to bridge that gap and identify a road forward. In *Hekonn* ("greed" in the Ga dialect of Ghana) Margaret Allotey-Pappoe moves us beyond South Africa to consider the implications of what we learned for understanding the world and our selves better. *Hekonn* issues a challenge and charge

detail, Apocalypse, *Jonathan Anderson*

that arises out of an understanding of the past so that we might respond to the maladies of the world's present and the dark inclinations that might lurk in our own hearts.

detail, Hekonn, *Margaret Allotey-Pappoe*

Constructing Hope by Magdel van Rooyen captures this well. Our world is in a continuous state of decay where forces of every kind act to break down the infrastructures that sustain our lives and very being. It is essential, even as we confront the sometimes overwhelming piles of rubble that need to be cleared away before restoration or something new can be built in its place, to maintain our hope in the promise that it *will* one day be made new.

Coloring the Wind

In the township of Gugulethu on the outskirts of Cape Town, the J.L. Zwane Church has established a program called "Colour the Wind." In essence, the church will arrange to paint a room in the homes of people dealing with some

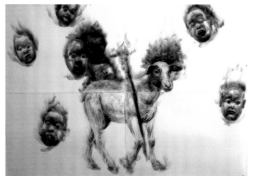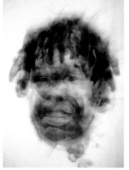

detail: Diane Victor, Like Lambs to the Slaughter, *2011, smoke on paper with charcoal, 140" x 66", Diane Victor© used with permission; Diane Victor,* Smoke Portrait, *smoke on paper with charcoal, Diane Victor© used with permission*
Diane Victor drawing with a candle, *2011, ©The Artist's Press, White River, South Africa, photograph: Mark Attwood*

sort of difficulty or distress. The residents can choose any color they like. When asked why they didn't just paint the whole house, the organizers responded that the purpose was to incite a fresh breeze to blow through. But that required the residents' follow through in claiming responsibility for the rest of the house. There

Duet, *Theresa Couture*

is wisdom here. As Charles Nkomo explains, what inspired his painting *Moment by Moment* was the dream of a different reality that sustained the South African people through their long period of oppression and struggle. But "Colour the Wind" also has implications for art. If a mere change of the color of one's walls can inspire hope and the will to act, what more could works of art do that present a vision of what might be possible? In her piece *Duet* Theresa Couture makes manifest harmony that is rich and complex. The sonorous

detail, Constructing Hope,
Magdel van Rooyen

result, with modulations in color and texture that seem to blend effortlessly, presents yet another vision of unity in diversity. It calls to mind the ancient philosophical and age-old Christian concept of the "Music of the Spheres" where the entire universe moves in dynamic yet harmonious relationship.

Kimberly Vrudny's work titled *Beauty's Vineyard*, by comparison, casts that vision down to earth. It reminds us that restoration and renewal depend on addressing the evil that ensues all around us. It requires that we work to bring about change that is needed wherever we encounter suffering, want and harm. And it shows through the black and white of the images of our present state that the new world we aspire to cultivate is both vibrant and real. The placement of the protea flower at the center of this piece says it all. Protea is a genus of flower indigenous to South Africa. It is among the oldest families of flowers on earth. It takes its name from Proteus, the son of the Greek god Poseidon, who had the power to know all things past, present and future, and could change his shape at will.

With more than 1400 varieties, the protea embodies great diversity and a multiplicity of possibilities within a single genus. You will see many other images of the protea in this exhibition because it came to stand for the possibility, however latent, for human and

...on the outskirts of Cape Town, the J. L. Zwane Church has established a program called "Colour the Wind." In essence, the church will arrange to paint a room in the homes of people dealing with some sort of difficulty or distress.

societal flourishing in South Africa and the whole world that just requires cultivation. It is the antithesis of barbed and razor wire.

Kimberly's title, *Beauty's Vineyard*, however, suggests the nature of the task at hand. A vineyard requires careful tending: selection and preparation of the soil, planting of the root stock, grafting and pruning, monitoring the weather to adjust for slight shifts in temperature or rain. Perhaps most essential of all, a vineyard requires watching and waiting patiently as the vines grow before they bear fruit and the grapes can be pressed to make wine. A single disaster could seem to undo it—heavy rains that cause mold, drought, fire or an unexpected freeze. It is an arduous undertaking; the threats innumerable.

Working to bring about a better world is no different. It takes hard work and resilience. It takes faith *and* hope. And as Philip Yancey explained in "What Art Can—and

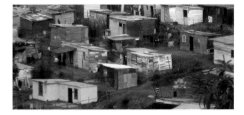

Can't—Do", art may play a significant role. It can prompt us to root out that which undermines our flourishing by revealing that which we need to see. It can also nurture that vitality by providing a vision of the "permanent things" that always remain good and true. It can color the wind. But Yancey also cautions that despite all that art can do so very well, it has its limits. As South African writer Alan Paton, author of *Cry, the Beloved Country* has written, "[art] will illuminate the road, but it will not lead the way with a lamp. It will expose the crevasse, but not provide the bridge. It will lance the boil, but not purify the blood. It cannot be expected to do more than this; and if we ask it to do more, we are asking too much."[12] "To know and not to act is not to know,"[13] said Neo-Confucian Scholar Wang Yangming (1472-1529). Or as Chinese artist and dissident Ai Weiwei puts it today, "The world is not changing if you don't shoulder the burden." It is, in the end, up to each one of us to take up the challenge presented by what we know to become agents of grace and change in the life we share. But as Johan Horn of South Africa told us, often "the question is not what am I to do but *who* am I called to love?" as we walk between the shadow and the light together.

> *...it was Khoisan's poetic zeal in describing the relationship between art and the pursuit of a more just world that directed our understanding of how artists may serve as both prophets—as harbingers of change—and seers...*

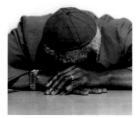

Archbishop Desmond Tutu crying during the hearings of the Truth and Reconciliation Commission, *Cape Town, South Africa, from* Beauty's Vineyard, *Kimberly Vrudny original photograph by Jillian Edelstein © used with permission*

NOTES

[1] From a talk by Jeremy Begbie titled "Subversive Hope: Embodying and Reimagining God's New World through the Arts" at Taylor University on November 10, 2009. I Fagiolini simply means "little beans" and SDASA stands for the Seventh Day Adventist Students' Association.

[2] www.ifagiolini.com/projects/simunye/ (accessed May 1, 2014).

[3] Ibid.

[4] Lynda Schuster, *A Burning Hunger: One Family's Struggle Against Apartheid* (Athens: Ohio University Press, 2004), 453.

[5] Philip Yancey, "What Art Can—and Can't—Do", *First Things* (February 2009), 34.

[6] Ibid., 35.

[7] www.mg.co.za/article/2013-12-10-robben-island-mandela-memorial-calls-for-reconciliation (accessed August 28, 2014).

[8] For the full text see www.judithmason.com/assemblage/5_text (accessed July 14, 2014).

[9] Begbie, op. cit.

[10] www.examiner.com/article/shared-interest-awards-father-michael-lapsley (accessed August 28, 2014).

[11] www.freerangelongmont.com/2012/10/16/international-hero-for-peace-and-healing-father-michael-lapsley-to-speak-in-boulder/ (accessed August 25, 2014).

[12] Yancey, op. cit., 35.

[13] Quoted in *Burger's Daughter* by Nadine Gordimer (1979).

"To know and not to act is not to know."

—Wang Yangming (1472-1529), Chinese Neo-Confucian Scholar
Quoted in *Burger's Daughter* by Nadine Gordimer (1979)

blow the vuvuzela
sound the alarm at South Africa's gate
there are reasons for the streets to feast
and reasons too to weep

let no one be misled: this nation is a miracle
never in history has a people come out
of so long a slavery, such bitter a deception
with an open hand and forgiveness in the heart
in no other land has covenant coloured over a multitude of sins
with rainbow blood
and the vengeance of atonement

but these—these are against you:
you have light but you are blind
you are rich but you are poor
you have dashed your brother with iron teeth
with a cutting load you have cut him
and Yisrael you have scorned

the corruption of your bowels is sick
no fragrance can hide the stench
of how you've forced your way
onto the destitute and orphan
onto your babies and widows and poor

the son who begs you for the bread of affection
you have stoned him for his hunger

consider your ways
remember the rock from which you were hewn
Adam and his seed
remember the prophet's promise:
a road of holy life will burn from Cape Town to Jerusalem
not by might, nor by power, but by the love of Holy Spirit
for Messiah's glory alone

come, let us rise to dance with heavy hearts
let us meet to mourn with laughter
let hope mingle with tears

come, let us pray

—Kambani Ramano
*Of Nsenga and Venda parentage, Kambani Ramano is learning
what It means to be in the image of the Poet who crafted creation
with words. He lives in South Africa (used with permission)*

Artists as Prophets and Visionaries:
An Ubuntu-*Inspired Renewal of Christianity*
Kimberly Vrudny

Another world is not only possible, she is on her way.
On a quiet day, I can hear her breathing.
—Arundhati Roy

Lauryn Hill, in her performance of *Motives and Thoughts* for an episode of HBO's *Def Poetry Slam* in 2006, spoke about the role of "wicked theology" in the construction of systems of oppression that are at the root of the suffering of the poor and marginalized in today's societies. She critiques the "negative imagery" that feeds human society, imagery that is "holding us down." The modern world is marked by "social delusion, clearly constructed," she writes, noting a "human condition" with "morals corrupted." The conceptions we have of the world, fed to us from youth, trap us, causing us perpetually to react, Hill believes, with "lawlessness and war," resulting in "dissatisfaction," she says, "from bowels to core." She indicates that the problem is a mindset the oppressor has chosen—a mind, she finds, that is "designed to stay closed," as a "global economy, in it for self," builds "industrial wealth" enabling "vice and corruption [to] take over the world."

> Blind with the wickedness, deep in your heart
> Modern day wickedness is all you've been taught
> Lied to your neighbors, so you get ahead
> Modern day trickery is all you've been fed

"Motives and thoughts," she concludes. "Check your motives and thoughts." [1]

I thought of this poem during the "R5" seminar sponsored by the Nagel Institute for the Study of World Christianity. Intentionally immersed for two weeks in an ethnically and culturally diverse community of artists and scholars from Ghana, Kenya, Nigeria, Zimbabwe, Botswana, South Africa and the United States, we together explored themes of reconciliation, remembrance, representation, resistance and re-visioning through the arts of South Africa. In doing so, we navigated racially demarcated landmines not always gracefully, and theologically constructed assumptions not always thoughtfully. Nonetheless, we shared, I sensed, an enormous collective trust in and hope for the power of the imagination to envision and, ultimately, to create a better world, despite the complex, multidimensional social, political, economic, and

> *...we shared, I sensed, an enormous collective trust in and hope for the power of the imagination to envision and, ultimately, to create a better world, despite the complex, multidimensional social, political, economic, and religious strands interweaving and threatening always to divide such a vision.*

religious strands interweaving and threatening always to divide such a vision. We were, in other words, wonderfully flawed, and wonderfully beautiful. For two weeks, we attempted to live out a multiethnic vision of mutual respect, cooperation, and hope—and it was magnificent. I remember waking just before 3:00 a.m. when our African friends departed for the places they call home. Tears rolled down my face as their bus pulled away. I knew we were losing something precious, something we could never experience again, at least not together and in the same way. And I experienced this as a great loss.

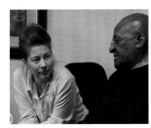
Kimberly Vrudny with Archbishop Desmond Tutu during the R5 seminar in Cape Town

The poem came to mind during the seminar because I am aware of the role of "wicked theology," to borrow Hill's term, in constructing apartheid law, as well as the sin of structural racism in perpetuating a vision of society "separate but equal." Despite this, I am hopeful in

the transformative potential of a thin Christian tradition that has been preserved alongside more authoritarian and imperial models of the same. So in this essay for the catalog accompanying images created by participants in the seminar, as both a theologian and an artist, I would like to offer some reflections grounded in South Africa's struggle in order to suggest a path for artistic engagement within Christianity for the next decade or more. By identifying the dangerous theological roots operating at the core of political systems like apartheid, and by contrasting them with a theology informed by principles of *ubuntu* in conversation with an examination of the human condition, my hope is that we can renew the tradition in light of a revitalized understanding of the radical love of Christ, and live out more perfectly the mandate to allow such atrocities to occur *never again*.

One of the seminar's stated goals was to ignite something of a renewal in Christianity and the arts, at least among its participants. In other words, the organizers hoped, I think, to inspire artistic work among those of us assembled that would affirm the relevance of the Christian message in the globalized context in which we find ourselves—work that would grapple with issues emerging from the post-apartheid era,

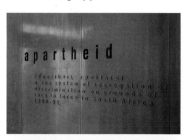

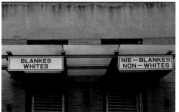

its creators having encountered people still traumatized by the "dangerous memories" of the past even as South Africa's citizens, black, white, and every color in between in the modern "rainbow nation," walk together into their common destiny.[2] That this common future is fraught with uncertainty is, I'm sure, lost on no one. Such a renewal in Christianity and the arts will require, I think, an understanding of the faith's relevance for the modern world, and it will require a sincere examination of motives

and thoughts at the base of the Christian religion—for all religions, Christianity included, can be and have been used for ill, just as they can, and will again, be used for good.

Wicked Theology

As familiar as people are with the governmental system that ruled South Africa from 1948-1994, brutally separating people on the basis of coloration of the skin while inflicting torture and murder to put down resistance, relatively few recognize that among the architects of apartheid were theologians who were constructing the religious scaffolding for apartheid law from their respective theology departments at Stellenbosch University and the University of Pretoria. Hendrik Frensch Verwoerd (1901-1966), often called "the architect of apartheid" for his role in developing the policies that would be implemented for the next half century, first as the so-called "minister of native affairs" under then-Prime Minister Daniel Malan, and then as prime minister from 1958 until his assassination in 1966, had received his bachelors degree in theology from Stellenbosch (called Victoria College at the time). He then studied psychology and philosophy at the graduate level. From 1928-1937, he served as a professor of sociology and social work at the University of Stellenbosch.

The philosophy of ubuntu *emerges from an understanding of justice as restorative, and undergirded South Africa's truth and reconciliation process. Based on Africa's ancient legal practice of resolving conflict by finding "justice under a tree," where those locked in conflict met with the traditional elders of the community to find a resolution that satisfied all parties, perpetrators and victims, alike...*

Understanding the power of a religious ideology and identity to unite a people, Verwoerd eventually called upon his colleagues in the theology department at Stellenbosch, as well as in Pretoria, to provide the theological rationale for apartheid law then taking shape in his own imagination as well as in the minds of his friends in the National Party—a rationale that would need also to be dismantled theologically. These theologians interpreted particular passages in the Bible, namely, the story of the Tower of Babel, the account of the Pentecost, and teachings about the Kingdom of God, to call for the implementation of apartheid law. Although these interpretations were immediately challenged on theological grounds, they took hold in the Afrikaner imagination and ultimately infiltrated the Dutch Reformed Churches. People were taught that, since God separated people into different language groups at Babel, and since the languages were not united at Pentecost, the Bible was clear that Christian unity was to be postponed to the end times. In the meanwhile, God wished us to live separately. Thus, apartheid was rationalized on Christian grounds. Separate development would rule the day, with the support of a majority of Afrikaners.

The dismantling of this "wicked exegesis" saw a quickening in the 1980s. In 1982, the World Alliance of Reformed Churches (WARC) met in Ottawa, Canada, for a conference on "Racism and South Africa." The General Council adopted a document that reads, in part, "We declare with black Reformed Christians of South Africa that apartheid ('separate development') is a sin, and that the moral and theological justification of it is a travesty of the Gospel and, in its persistent disobedience to the Word of God, a theological heresy."[3] Theologians like Desmond Tutu and Allan Boesak used historical-critical methods of reading the Bible to interpret Babel in its primeval context, and as an ancient means to explain the existence of differing linguistic groups. Likewise, they conveyed that the Pentecost functions to unify humankind in the language of the Spirit of God. Pentecost is Babel's grand *undoing*, with implications for how we are to live as disciples of Christ in the here and now, God's kingdom "already," even if "not yet."

Ubuntu-Inspired Theology

Despite the ways that Christianity was contorted to serve the purposes of the apartheid state, South Africa's modern history sheds light on the paradoxical way in which the Christian story remains deeply relevant. So we turn to South Africa, and to its theology of *ubuntu*, for help in making sense of the Christian story. In the philosophical traditions of sub-Saharan Africa, there is a concept that was made more widely known throughout the world by Nelson Mandela in leading his country's "long walk to freedom" from the tyranny of apartheid.

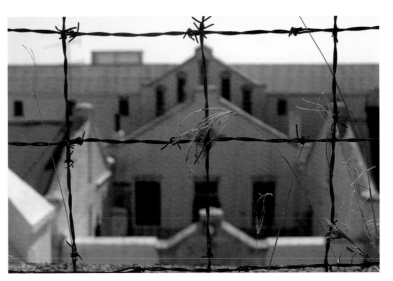

Ubuntu is the Zulu word that expresses the understanding that we are human through other people. It expresses the idea that "I am because you are." We are dependent upon one another for our very being. According to the thinking of *ubuntu*, we are all born into an intricate, luminous, and radiant web of interconnectedness, in such a way that where the being of one is diminished, all are diminished, and where the being of one is nourished, all are nourished.[4]

The philosophy of *ubuntu* emerges from an understanding of justice as restorative, and undergirded South Africa's truth and reconciliation process. Based on Africa's ancient legal practice of resolving conflict by finding "justice under a tree," where those locked in conflict met with the traditional elders of the community to find a resolution that satisfied all parties, perpetrators and victims, alike, these African ideals of justice attempted to restore all parties to peaceful relations in community with one another.[5] Rather than concerning themselves primarily with the punishment of wrongdoers, as is true with

Parishioners gathering in the courtyard "under the tree" at Regina Mundi Roman Catholic Church in Soweto before Sunday morning mass

retributive models of justice more familiar to Westerners, elders desired to prevent further fragmentation of the community. *Ubuntu* is concerned about the one against whom a violation has occurred— and how properly to redress the anguish borne of violation. *Ubuntu* prompts members of the community to ask: What can be done to heal society, so that all within a community can flourish again—survivors and perpetrators alike?

In a framework informed by the philosophy of *ubuntu*, when a violation has occurred, restoration of community moves through two distinct phases: forgiveness and reconciliation. Forgiveness does not mean that the violation is forgotten. Rather, forgiveness means that the one who has been violated is "letting go." This is not a one-time act but, rather, this is a spiritual discipline. When feelings of anger and resentment and vengeance surface, as they naturally will, the one who

has been wronged practices the release of feelings of hurt, anger, and vengeance. Forgiveness therefore empowers the one who has been violated, so that he or she does not hand power over to the violator by waiting for an apology that may never come, or for recompense that may never be paid. Forgiveness functions to end a cycle of violence, and opens the possibility for relationship to emerge again.

The philosophy of *ubuntu* is clear, however, that forgiveness does not constitute reconciliation. Just because many of African descent have forgiven those of European descent does not mean that healthy relationship between the two is immediately or magically restored. Such a relationship, if genuine, takes a great deal of time to reestablish (if it ever truly existed in the first place). Reconciliation is often a slow and arduous process. Reconciliation entails the development of trust and friendship between two communities after an adequate accounting has been heard, and after an adequate restitution has been paid.

> "[T]here is an awful depth of depravity to which we all [can] sink….[W]e possess an extraordinary capacity for evil….[T]his applies to all of us. There is no room for gloating or arrogant finger-pointing.… [T]hose guilty of these abuses were quite ordinary folk. They did not grow horns on their foreheads or have tails hidden in their trousers. They looked just like you and me."
>
> —*Archbishop Desmond Tutu*

The Human Condition

A theology informed by principles of *ubuntu* informed South African activist and Anglican Archbishop Emeritus Desmond Tutu when he led his country's truth and reconciliation process. After citing episode after episode of torture and murder under apartheid in his book *No Future*

Without Forgiveness, he wrestles with the question of what it means to be human. He writes, "[T]here is an awful depth of depravity to which we all [can] sink."[6]

> [W]e possess an extraordinary capacity for evil. … [T]his applies to all of us. There is no room for gloating or arrogant finger-pointing…. [T]hose guilty of these abuses were quite ordinary folk. They did not grow horns on their foreheads or have tails hidden in their trousers. They looked just like you and me.[7]

Tutu is struggling with age-old questions. Who are we, by nature? Do we carry in us a divine spark—the *Shekinah's* flame, to use the words of Jewish theologians—the *imago Dei*? Is its light diminished by the power of sin, or made more radiant through a sanctifying transformation? Or are we, finally, all of us monsters and monstrous—carrying in us, given a certain configuration of circumstances, an untold capacity for cruelty, barbarity, and savagery? Are we then monsters and monstrous by nature—or is this monstrous capacity merely a potential within us, only sometimes realized? To what depths are we able to sink in order to protect our tribes from scarcity and want? At what point does this attempt to protect one at the expense of another begin to constitute sinfulness? Are our definitions of sin adequate for examining this kind of violation against the will of God?

Like Tutu, Jane Alexander is a South African who has inquired into the nature of the human person. As an artist, she creates works that, while not explicitly religious, might be sources for those of us who are pressing the boundaries of the anthropological

It is said that poets write of beauty,
of form, of flowers and of love
But the words I write
Are of pain and of rage…

—James Matthews—
'CryRage'

question theologically. Her work from the 1980s, for example, addresses the ways in which racism dehumanizes everyone it touches. It is obvious how apartheid dehumanized people of color. The stories that unfolded publicly during the Truth and Reconciliation Commission of the countless indignities—the passbooks, the forced removals, and the surveillance, and the gross human rights violations—the tortures, the rapes and the murders, all make the dehumanization of the black person and other people of color under apartheid extremely clear. But in what is almost certainly her most famous work, the *Butcher Boys*, Alexander expresses that which is less clear. How did apartheid dehumanize people with white skin? They were privileged by the system, after all. People with white skin were able to access a quality education, good jobs, and prime real estate—hardly an image of dehumanization.

In her sculpture, Alexander presents three figures seated on a bench. They are naked, and have bodies of men, though the chest of each one

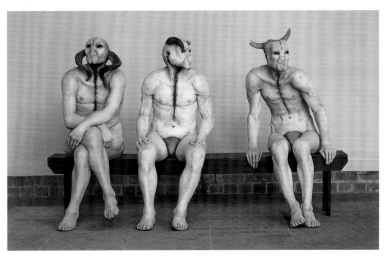

Jane Alexander Butcher Boys, *1986,*
mixed media, life-size
Art © Jane Alexander / DALRO, South Africa/VAGA New York
photograph: Mark Lewis

Humanity was born in Africa.
All people, ultimately, are African.

Folks who are privileged by systems on the basis of pigmentation might be identified, too, as oppressors by virtue of the color of their skin. In these ways, people of privilege have been dehumanized by racism.

In this way, racism diminishes everyone by systemically diminishing one's sense of worth and value while simultaneously increasing another's access to power and privilege, all on the basis of skin tone and by the use of brutality. In either case, racism fails to recognize the inherent and inviolable dignity of every human person, all of whom are created in the image of God. Thus, the liberation of all people is bound up in overcoming racism, as Australian Aboriginal elder, Lilla Watson, observed decades ago when she said: "If you've come to help me, then you're wasting your time. If you've come because your liberation is bound with mine, then let us work together."

is scarred, as if his heart has been torn out and he has been sewn up again. Their heads appear monstrous and alien, with horns protruding from their skulls, their mouths and noses muffled by overgrown skin, their genitalia capped. Produced at the height of the violent conflict that would eventually bring about the end of apartheid, the artist presents the perpetrators of apartheid as part-human, part-monster. The title informs us that they were not just monsters, but butchers. They look arrogant, as if they are entitled to persist in conducting their affairs on behalf of the state. One shifts threateningly in his seat. They are a menace, and menacing. By wreaking social havoc, they make everyone, ironically, less secure.

But the artist may be providing a commentary on more than the inhumanity of those who were part of the police services. If the *Butcher Boys* are also understood to represent, more broadly, those whose silence enabled the savagery to persist, then the artist seems to be saying something about the power of racism to affect the soul of every person it touches—for all are impacted by systems that advantage some to the disadvantage of others. By accident of birth, the privileged participate in systems that dehumanize. So they, too, are guilty by association. If they are not working to extend the privileges they enjoy, their souls might bear a resemblance to the *Butcher Boys*.

Christian Renewal

South Africa's tumultuous history points to the relevance of Christianity for the modern day. It provides significant material for Christian artists and theologians to explore in their work. If Christianity began to wrestle sincerely with complicity as a category of sinfulness, if those with access to power and privilege because of the systems as they stand began to grapple sincerely with the question of how their liberation is bound together with the liberation of those they oppress, and on the

The Orb of Sovereignty near the entrance to St. George's Cathedral in Cape Town

backs of whom their privileges are purchased, Christian doctrines of Christ and salvation might begin to wrestle with how the nature of Jesus Christ saves sinners from a sinful condition that includes complicity in sinful structures. Christians would have to interrogate what role, if any, the cross plays in saving humankind from this sinful condition. And Christianity would have to reimagine, too, the work of the Holy Spirit among us. We would have to ask how the Spirit is cleansing us from this insidious structure that has so deformed us, and into what form the Spirit is shaping us.

> *Forgiveness opens the possibility for restored relationship—whether among people torn apart on the basis of the color of skin in the political economy of South Africa, or between God and humankind in the realm of Christian theology.*

South Africa's process of truth and reconciliation challenges how Christians might construct a theology of redemption. Just as many South Africans have forgiven those with white skin because, operating within an *ubuntu* framework, they recognize that failing to forgive destroys by corrupting the heart that seeks for vengeance, so might we consider the possibility that Jesus came to communicate God's forgiveness. God's forgiveness may have been expressed throughout Jesus' life and ministry, even to the point of Jesus asking God the Father to forgive those who tortured him, for he realized they knew not what they were doing (Luke 23:34). God's forgiveness might not be forestalled until after the crucifixion. Jesus appeals for the Father to drop the charges against humankind, just as the charges were dropped in many cases against those who committed gross human rights violations under apartheid.

Forgiveness opens the possibility for restored relationship—whether among people torn apart on the basis of the color of skin in the political economy of South Africa, or between God and humankind in the realm of Christian theology. Just as the forgiveness offered by some Xhosa-speaking people in South Africa, to give but one example, creates a place of safety for Afrikaans-speaking people to acknowledge how they participated in systemic dehumanization, so does God's forgiveness of a sinful humankind open a path to reconciliation. God desires for the relationship to be restored—but this takes time, just as it will take time to heal the population of South Africa. This is what the Christian tradition has referred to as "sanctification." It is a process by which one is made holy by entering into relationship with God anew after the violations of a sinful past. The culmination of the process of reconciliation is what the author of the book of Revelation refers to as a new heaven, and a new earth, "Then I saw a new heaven and a new earth; for the first heaven and the first earth had passed away, and the sea was no more. And I saw the holy city, the new Jerusalem, coming down out of heaven from God, prepared as a bride adorned for her husband" (Revelation 21:1-2).

Stained Glass at Regina Mundi Roman Catholic Church in Soweto

Radical Love

What such a new heaven and a new earth might look like is suggested in one of the novels that the designers of the R5 seminar in South Africa recommended to participants. *My Traitor's Heart* is a memoir that speaks to contrition, to a deep sorrow, in the heart of one of South Africa's white sons, Rian Malan, and to his transformation from a butcher boy, of sorts, to someone more like Christ (at least in ideal terms). In

detail, The Journey to Freedom *narrative project, Intuthuku Embroiderers and Gwenneth Miller and Celia de Villiers (UNISA), 2003-2007*

his memoir, Rian Malan sketches what this kind of spiritual journey—of conversion, of transformation, of redemption—can look like.

As the descendant of one of apartheid's most infamous architects, *My Traitor's Heart* traces Rian Malan's attempts to eliminate all traces of racism from his soul by crossing the color line. Not unlike Socrates' journey to hear the wise words of Diotima on love in *The Symposium*, Malan journeys to Zululand to hear the wise words of Creina Alcock. Malan explains that Neil and Creina Alcock

> had spent two decades living among Africans, trying to undo some of the harm done by

"Constitutional Court" in the eleven official languages of South Africa on the entrance facade of the Constitutional Court building in Johannesburg

apartheid. They lived in mud huts and shat in holes in the ground. They washed their clothes and bodies in the Tugela River and drank its muddy water. Visitors found flies and ants in the sugar bowl and boiled tadpoles in their coffee....They were as ragged as the black peasants among whom they worked, and thinner to boot. They were the only whites in the country who lived beyond all suspicion of complicity.[8]

When he finally reached her, Malan simply said, "I want to know . . . what you have learned here?"[9] Not sure at first that she would even entertain his question, he spent the night awed by the privileges the Alcocks had forsaken. His patience was rewarded with hours of Creina's reflections on tape, including her climactic speeches on love. "She believed in love, you see; not in a sentimental sense, or a religious sense, but just . . . love; giving of yourself and trying to do good for others. Her and Neil's willingness to love had carried them deeper into Africa

> *"'The path of love is not a path of comfort.' Rather, love "'means going forward into the unknown, with no guarantees of safety, even though you're afraid. Trusting is dangerous, but without trust there is no hope for love, and love is all we ever have to hold against the dark.'"*

than any other whites, and she thought love would protect them there".[10] But when a bullet in a conflict between the Mhlangaans and the Ndlelas killed Neil, Creina wondered for a time if it had all been meaningless. She nearly gave up, and thought about resuming her life in white society. But she didn't. She explained to her disciple,

> I thought, if you're really going to live in Africa, you have to be able to look at it and say, This is the way of love, down this road: Look at it hard. This is where it is going to lead you. . . . You said one could be deformed by this country, and yet it seems to me one can only

be deformed by the things one does to oneself. It's not the outside things that deform you, it's the choices you make. To live anywhere in the world, you must know how to live in Africa. The only thing you can do is love, because it is the only thing that leaves light inside you, instead of the total, obliterating darkness.[11]

Malan took away the lesson that "'The path of love is not a path of comfort'."[12] Rather, love "'means going forward into the unknown, with no guarantees of safety, even though you're afraid. Trusting is dangerous, but without trust there is no hope for love, and love is all we ever have to hold against the dark'."[13]

———

This kind of radical love is at the heart of the ongoing relevance of the Christian story for the modern world. And it is here that artists have a vital role to play—a role that is both prophetic and visionary. Behind these reflections is the hope that Christian artists and theologians

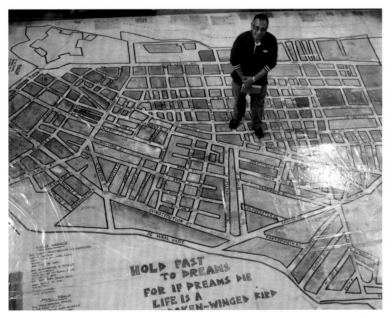

The R5 on-site coordinator for Cape Town, Keith Sparks, at the District 6 Museum

alike will question their "motives and thoughts" and participate not in the perpetuation of the wicked, but in a renewal of Christianity by reimagining the Christian tradition, informed by lessons from South Africa in relation to the sin of structural violence and its redemption through a politically engaged Jesus who preached about a kingdom of God, a kingdom that has very real, earthly dimensions.

Christian artists, as prophets and visionaries, can empower us to live into a new reality where structures harm us no longer but enable all of God's children, of every language, color, gender, class, preference and creed to prosper and to thrive. Like Jane Alexander, artists can contribute to the creation of the peaceable kingdom as prophets, exposing the dangerous teachings that have been used to support racist governments like the former one in South Africa. And like Rian Malan, artists can contribute as visionaries, imagining a still more excellent way of being human, such that we can live into the future they envision for us. Inspired by an artistic perception informed by principles of *ubuntu*, and functioning now as Christ's merciful hands and feet, Christians can choose to work for greater justice by becoming a compassionate presence in the world, thereby transforming and restoring it to God's original vision for it—a True, Good, and Beautiful community of just and loving relationships.

With the one who walked this way before taught us, and with ever greater urgency, Christians pray, "Thy kingdom come, thy will be done, on *earth*, as it is in heaven" (Matthew 6:10). A new world is possible.

> ***Easy Mornings***
>
> *(i)*
> *Let go*
> *Walk in the rain*
> *Dream a bright*
> *New day*
>
> *(ii)*
> *Open hearts*
> *Ready to embrace*
>
> —*Zenzile Khoisan, November 1999*
> (used with permission)

39

Christian artists, as prophets and visionaries, can empower us to live into a new reality where structures harm us no longer but enable all of God's children...to prosper and to thrive....artists can contribute to the creation of the peaceable kingdom as prophets, exposing...dangerous teachings...[and] artists can contribute as visionaries, imagining a still more excellent way of being human, such that we can live into the future they envision for us.

She is on her way. By envisioning it, with their prophetic and visionary imagery, artists are contributing to her creation.

NOTES

[1] Lauryn Hill, "Motives and Thoughts," www.youtube.com/watch?v=HpXJs3CtDfE (accessed February 7, 2014).

[2] "Dangerous memories," along with "interruption," are concepts coined by Catholic theologian Johann Baptist Metz. For a helpful summary of Metz's thought, see Bryan Pham, S.J., "Political Theology: Interruption," www.guweb2.gonzaga.edu/metz/theo.html (accessed February 7, 2014).

[3] See "Appendix: Documentation," in de Gruchy and Villa-Vicencio, *Apartheid is a Heresy*, John de Gruchy and Charles Villa-Vincencio, eds. (Grand Rapids: Eerdmans, 1983), 170. For a discussion, see Megan Shore, *Religion and Conflict Resolution: Christianity and South Africa's Truth and Reconciliation Commission* (Ashgate, 2009), 53.

[4] See Michael Battle, *Reconciliation: The Ubuntu Theology of Desmond Tutu* (Cleveland: Pilgrim Press, 1997). The language of a "luminous web" comes from Barbara Brown Taylor, *Luminous Web: Essays on Science and Religion* (Cowley Publications, 2012).

[5] Desmond Tutu, *No Future Without Forgiveness* (New York: Doubleday, 1997), 54-55.

[6] Ibid., 144.

[7] Ibid.

[8] Rian Malan, *My Traitor's Heart: A South African Exile Returns to Face His Country, His Tribe, and His Conscience* (New York: Grove Press, 1990, 2000), 342.

[9] Ibid., 343.

[10] Ibid., 397.

[11] Ibid., 409.

[12] Ibid., 423.

[13] Ibid.

facing page
Jackie Karuti
detail, *Stefaans' Letters* 2013

R5

Reconciliation:
persistent questions over how to justly reconcile aggrieved people

"...suffice to say, we have built something from nothing
We the ordinary people we have made a road, by walking..."

—Zenzile Khoisan, poet and Chief Investigator,
Truth and Reconciliation Commission
in *Fare Thee Well* (September 1998)

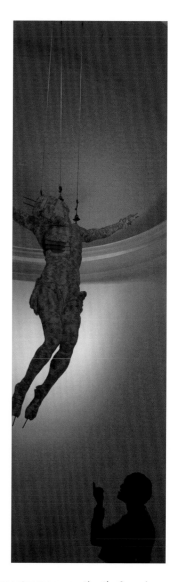

left to right: Archbishop Desmond Tutu, the Isisivane stones representing the 9 provinces of South Africa at Freedom Park in Pretoria; detail Synchronic Journey (2009) by the Intuthuku Embroiderers with Celia de Villiers; Commune: Suspension of Disbelief (2001) by Wim Botha

Artists & Artworks

Guard your heart with all diligence, for everything you do flows from it.
—Proverbs 4:23

Margaret Allotey-Pappoe
Ghana/United States

INHABIT: shantytown--Awo

The sixteen-hour air travel to South Africa seemed very long but exciting. I had no idea what to expect and nothing had prepared me for what I was about to experience. Even though I was born and raised in Africa a lot of things still surprised me. I witnessed extreme poverty, pain, disappointment, anger, and sickness, among many other things. Many South Africans have been caught up in these unfortunate circumstances through no fault of their own. In spite of that, I found the South Africans to be a very resilient people, and that was amazing to me. One of the moments that stood out to me was the day we visited the HIV/Aids group at J.L. Zwane Memorial Church in Gugulethu, a township outside of Cape Town. I felt very humbled when I listened to them share their stories of abuse, rejection, scorn, fear, and so on. At the same time, and perhaps most importantly, their stories ignited hope and love and that reminded me of the love that is described in I Corinthians 13:7(ESV): Love bears all things, believes all things, hopes all things, endures all things.

I have learned since coming back to listen to other people's stories and to not form opinions based on their looks. I am much more receptive and responsive to those in difficult situations. I find it hard these days to turn a blind eye to difficult circumstances. My journey to South Africa reminds me daily to be continually thankful and to appreciate the value of life in a much deeper way.

I titled this work *Hekonn* which is a word meaning greed in the Ga dialect of the Ga Adamgbe tribe of my home country, Ghana. This print was designed to challenge viewers with the idea that most of us have become passers-by while we look on and see others suffer while a few greedy and inconsiderate persons manipulate the system. The triangular grid structure represents the unstable and fragile condition of society. The drawings with triangular heads represent humans walking by with chin up and ignoring everything around them—I don't care or I'm minding my own business attitude. Words were used to grab the attention of the viewer to seriously think of things that are defining our world today. We do not have to accept it and think we are powerless. Each of us should speak up in our own small way to reverse some of these hurtful situations to make the world a better place. If we stand together we can do mighty things.

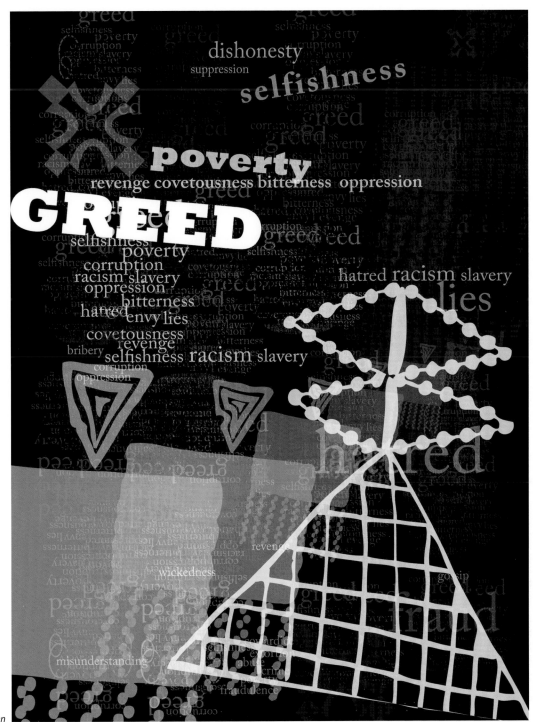

Hekonn

Jonathan Anderson
United States

Our time in South Africa had the marvelous effect of making me uncomfortable in my own cultural skin. The sites and people we visited were so extraordinarily diverse (even divergent!) that my sense of social know-how was quickly destabilized. Being present in a place as a stranger forces much of the enculturation that normally operates in the background of one's everyday life to suddenly become conspicuous: one's manners of speaking, thinking, and relating to

others (and one's assumptions about what meanings these carry) are no longer simply "givens" but are brought forward into plain sight as the rather contingent constructions that they are. I am attuned to this whenever I travel but I was especially so in South Africa, where its dense histories made me increasingly (wonderfully) self-conscious of the cultural lenses through which I attempt to understand the world.

But it wasn't only my own cultural framework that was made strange and contingent; South Africa presented itself in a wildly strange array of goodness and dysfunction. That country is such a potent example of how profoundly complex—and convoluted—the operations of systemic (structural) social virtues and vices can be as they shape and reshape human lives. While in South Africa, I kept finding myself reflecting on my own home city of Los Angeles, where many of the same complexities and convolutions are at play. In many ways it is most difficult to have clarity at home, where so much that is strange and objectionable about one's own culture (and one's participation in it) is able to withdraw again into the background of everyday concerns and routines. We are all in our own ways struggling to heal and to live life well with others, which necessitates keeping alert to the ways that our own communities might be otherwise. I returned to my home and to my studio with this very much in mind.

Robben Island, B-Section

This was painted after the announcement of the title for this exhibition: *Between the Shadow and the Light*. It depicts the courtyard of cellblock B of Robben Island Prison, where the highest-security political prisoners (including Nelson Mandela) were held during the apartheid era. The courtyard is now dilapidated and empty—an artifact of the failed apartheid state and its cruelties. In its empty state the prison resonates with histories of both oppression and liberation. The old structures remain in place, even if inhabited with new narratives and functions.

This painting is constructed such that the far wall of the courtyard (the lightest surface in the center of the painting) is unpainted bare canvas. This wall is thus both a kind of opening in the logic of the painting (an absence or hole in the representation) and a kind of barrier (the resolutely flat surface of the canvas). By conflating the (representational) surface of

above: Memorial
right: Robben Island, B-Section

Jonathan Anderson continued

Property Lines

the prison wall with the (material) surface of the canvas, the painting itself becomes a kind of obstacle: it both offers a way of seeing and restricts it. How does one represent the histories of Robben Island in the present with a particular interest in moving "beyond" them? How do we represent its histories—and the histories of apartheid in general—in ways that are both truthful (without being stultifying) and liberating (without being naïve)?

Apocalypse

Both of these photographs were taken in South Africa—the first on a street in Cape Town and the second looking into one of the remaining stairwells of the Old Fort Prison on the site of the

current Constitutional Court in Johannesburg. In the first image a drop of oil on wet blacktop creates a rainbow of concentric rings of color somewhat reminiscent of the rainbow aureoles that surround Christ in images of the last judgment (following the visions of the throne of God in Ezekiel 1 and Revelation 4). It appears as a kind of vacant planetary orb against the "starry" cosmic background of the asphalt. The second photo peers into the ruins of one of the most infamous buildings in the apartheid prison system (renowned for its abusive treatment of inmates). A circle has been removed from the photograph in the same location and size as the circular oil droplet in the first photo, creating an absence in the center of the image that reveals the bare ground of the paper on which the image appears. Both sides of the diptych resist "closed" interpretations of the way things appear (whether perceptually or historically).

Cape Town, ZA / Long Beach, CA

This is one continuous 12-foot strip of canvas installed such that half of it (the approximate height of a man) hangs vertically on the wall as a landscape painting and half of it extends horizontally out onto the floor, marking out a portion of the physical landscape of my studio (or now the gallery). On the vertical half I have painted a view looking out over the outskirts of Cape Town just before sunset. The horizontal half of the canvas recorded all of my movements in constructing the painting, including footprints, marks from my chair, paint drips, etc. In this way, the image overlooking Cape Town, ZA, remains intrinsically tied

continued on page 128

Apocalypse

Cape Town, ZA/Long Beach, CA

Keith Barker
United States

Commemoration

Eucalyptus trees, concertina razor wire, a tower of street-signs salvaged from a dismantled city, a crucifix carved from Bibles printed in eleven languages, hands and faces of people who have lived through remarkable change and uncertainty...these are some of the visual shards that caught my eye in South Africa which, in turn, helped me to make a little more sense of my own part of the world.

I see now how much South Africa mirrors the dichotomous tensions of Life. This young nation, whose constitution is not much more than twenty years old, is set in a land with a long, rich history. South Africans are no strangers to struggle, but they also grapple with how to seek reconciliation. While the country is a melting pot of languages, ethnicities, cultures and people groups, its history is full of slavery, bigotry and racial violence. It is the most developed and wealthy of any nation on the African continent but also shows equal extremes of poverty, extortion and corruption. Many of the world's richest natural resources are found within South Africa but their retrieval is at the expense of the poor and destitute. Each and every bright, promising facet seems to have a darker, more costly side.

Someone coming from the outside might easily fall into a mindset of looking for ways to fix the tensions and problems that afflict South Africa. But while the problems might be seen as unique to the country, I am beginning to understand how those same issues are common to my human experience as well. The South Africans we encountered generously shared personal experiences and perspectives of their homeland, and I found myself identifying with the tension evident in much of their stories despite the contextual differences. I realized that their stories embody our common human story. I see more clearly tensions resulting from my own interactions with others, and I am learning the importance of what I do in response to those tensions.

The Queens of Soweto

These muses, these South African "daughters of memory"—chatted in the shade on a bench after they had just served the sacraments during Sunday morning mass in the Regina Mundi Catholic Church in Rockville, Soweto. The conflicts and horrors endured by this "Queen of the World" church are marked in the walls and windows, as well as in the people and their memories. However, the faces and hands of these women show no conflict, though they hint at much experience and personality. My interaction with them supported that. With dignity they await my recording that moment.

The Queens of Soweto

Keith Barker *continued*

Few of the photographs I made in South Africa fully captured all that I saw and considered anew of the human condition. *Tension: On the Way to Robben Island* comes closest in my mind, in that it points to the ubiquity of dualistic elements of sky and water. This simple vantage looking off the coast of Cape Town seems to parallel the universality of the many human dichotomies I found in this fascinating country: rich and poor, old and new, freedom and slavery, remembering and forgetting, reconciliation and retribution, shadow and light.

Though it could have been taken anywhere sea and sky meet, this particular scene is nearly the one Nelson Mandela would have had on his boat ride to Robben Island. Whether he knew it or not, he was on his way to many years of imprisonment. He saw this view and wondered, I am sure, of what lay ahead for him and his country.

Commemoration

"I felt the presence of memories I could not remember. I am finding it a little hard to say that I felt [my forebears] resting there, but I did. I felt their completeness as whatever they had been in the world."
—Wendell Berry from *Jayber Crow* (2001)

This piece replicates the experience of commemorating a deceased relative one has never met. I initially recorded these moments out of not knowing what else to do—but still wanting to honor my grandfather Lilburn Adkins' life. The use of video exploits sound and time, and highlights a contrast between death—a sense of finality and absolute stillness—and life, shown persisting around and in spite of that death. One might wonder what Lilburn Adkins' life was like in South Africa, and how, when, and why he lived there.

Somewhere Else

This book encompasses the experience of my visiting South Africa, open to the complexities of its past present and future. Working on the juxtapositions, sequences and combinations of images mirrored and augmented those complexities, but helped me process the significance of how it all applies to me personally.

Tension: On the Way to Robben Island

Joseph Cory
United States

My artwork serves as an opportunity to examine visual metaphor and the carefully labored process of painting. My choice of materials, surface texture and quality, and the compositional strategies of reduced form and color is intended to invite my viewers to participate in the ambiguous nature of perception and to experience moments of reflection in a transcendent or poetic way. These meditations and the creative process allow me to negotiate my existence by creating a visual experience that helps slow down looking in order to find meaning.

Trespassers on Our Own Land is a painting about collective memory and displacement. It references the South African poet James Matthews' poem *We Watched the White Man's Arrival* from his book *Cry Rage*. The poem begins,

> *We watched the white man's arrival*
> *In strange-shaped ships we did not know*
> *Now we have become trespassers*
> *On the shores of our land*

We discussed Matthews and this poem during our debriefing time after visiting the District 6 Museum in Cape Town. Fellow "R5er" Jackie Karuti powerfully read part of this poem to the group and this stanza stuck with me because I felt like it represented a powerful metaphor for apartheid. The imagery of my painting is abstracted but references blurred figures wandering in an endless crowd to nowhere in particular as if trespassers within a fog or smoke.

All That Lies Behind Us is a reference to a line in Pablo Neruda's poem *There is No Clear Light*. Zenzile Khoisan, South African poet and Chief Investigator of the Truth and Reconciliation Commission, quoted the line from the poem in our conversation with him. Neruda's poem is about the dual nature of living in the present while still holding onto painful memories of the past. The poem ends,

> *of all that I was, I bear only these cruel scars,*
> *because those griefs confirm my very existence.*

The idea of an inescapable collective memory while trying to navigate present circumstances seems appropriate to the tension we discussed and observed. The imagery consists of blurred figures that are standing in a line. The destination of the figures is not described. I think this provides a powerful metaphor for the struggle to overcome apartheid, and the memories that now haunt the nation.

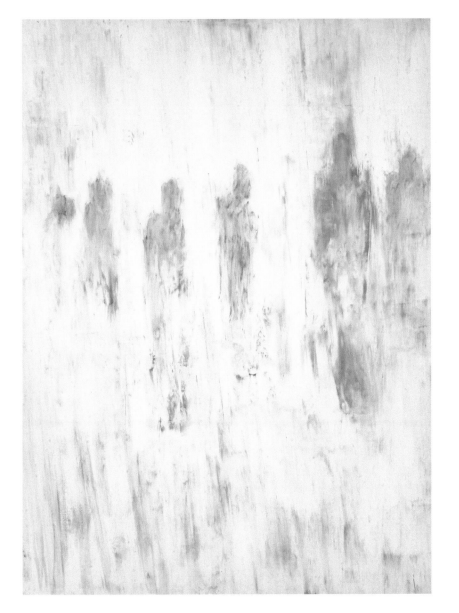

left: *All that Lies Behind Us*
right: *Trespassers on Our Own Land*

Joseph Cory *continued*

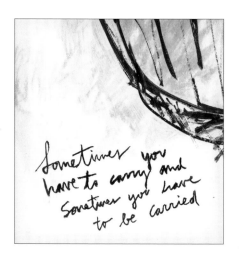

The Unnamed Few (after Judith Mason) is a direct reference to Judith Mason's artwork *The Man who Sang and the Woman who kept Silent* more informally known as *The Blue Dress* which hangs in the Constitutional Court in Johannesburg. The story behind the work of art impacted me in a very powerful way. I wished to create a small painting that referenced the story to contribute, in my own way, to the memorialization of the victim.

Winter Flower ZA drawings

These drawing were created during our studio days in Constantia. They represent abstracted protea flowers. The protea is South Africa's national flower named after the Greek god Proteus, who could change his form at will. The protea consists of a great variety of species, which can vary significantly in color and shape. I see this as a metaphor for the diversity of the South African people and the transformation of the nation. The title *Winter Flowers ZA* is in reference to my experience observing these flowers as they bloomed during the South African winter (the North American summer) in June. I liked the metaphor of a flower that blooms in the winter, typically experienced as a time of death and germination in the

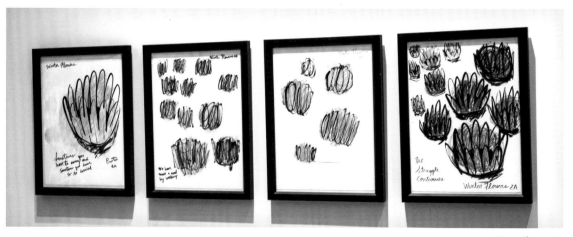

Winter Flowers ZA

colder climate of North America. For me this symbolizes hope amidst death which represents the struggle against apartheid. Many of the drawings consist of eleven flowers which symbolize the eleven official languages of South Africa. Several of the drawings have written quotations related to something I read or heard during my experience: "Sometimes you have to carry and sometimes you are carried" (Dumile Feni on his sculpture *History*), "we have made a road by walking" (Zenzile Khoisan in his poem *Fare Thee Well*), and "the struggle continues," a phrase our group encountered everywhere.

Judith Mason, The Man who Sang and the Woman who kept Silent (triptych), 1998, installation view, Constitutional Court, Johannesburg (used with permission)

The Unnamed Few (After Judith Mason)

Theresa Couture
United States

Through the work produced after my African sojourn, I have, with renewed intensity, felt the lure of that liminal space where alliances occur between the arts and religious imagination. More specifically, the pieces I have contributed to this exhibition emerge from defining questions about how the lyrical becomes a means for grasping and perpetuating perceived reality and personal responses to it. Never primarily concerned with recording phenomena or reifying contesting issues, lyric sets out to present, adequately and truthfully, the mind and heart caught in a moment of illumination along the flow of changing events and shifting emotions. Lyric invites a depth of concentration that aligns it to the spiritual quest.

As a visiting artist in South Africa trying to look at the stresses put on a host population by its history of conflict, fear, and betrayal, and its efforts at reconciliation, hope, and receptivity, I became attentive to the artistic inheritance that most universally lends equilibrium to communities of struggle. Face-to-face with symbolic representations of the raw nature of things, I caught glimpses of individual solitudes prophetically empowered with lyric insight. There were startling revelations of ordeal plunging toward triumph, of points of arrival not yet destinations, of writings in the sand unsparing of human limitation, yet shaped by the richness of human existence. And these have widened my own experiential base, that place from which I stand at the edge of the known, manipulating raw materials of art as a way of mediating between transient visual satisfaction and the sinuous grace of spiritual sensibility.

For me, to engage lyric most genuinely is to wander toward the Divine, astonished at every turn by the sheer possibility of encountering immanence and transcendence and submitting to their miraculous convergences. When making art, then, I am compelled to begin with long

continued on page 129

*Holy the Day--Morning Curtain: The Hour of Lauds
and Evening Cavern: The Hour of Vespers
right: Duet*

Katie Creyts
United States

While looking at contemporary South African art, a few themes surfaced. The first was the act and art of printmaking. Printmaking has a unique tie to this relatively young democracy as a means to create multiple images and/or text to connect people. The ability to share a visual language in a country that boasts eleven official verbal languages is important. The content of the high contrast images was variable. Some showed information relating to the spread of the AIDS virus or artful documentation of years of division, and then, the same with hopeful re-visioning of the future. Within the process of printmaking is the act of incising, cutting, etching away the plate. The process can be seen as a metaphor for pain or aggression, with the printing press transferring that energy onto the paper. I witnessed South Africans existing within a similar sort of tension. Another theme was the use of the color blue. At the Slave Lodge in Cape Town, now a museum, I was drawn to the wax resist indigo-dyed clothing. Then, in the Constitutional Court's art collection, I saw an artist who had rendered a dress from a humble blue plastic bag. The influence of the Dutch was ubiquitous with Delft blue china. The themes I mention are interwoven into art processes and identity with great complexity.

Being of Dutch descent, my parents' house is decorated with a fair amount of Delft china, and I began having post-colonial pangs of guilt about this decorative china as my brain re-contextualized it. The pattern of delft is a bit lawless, being busy with flourishes and intricacies of blue glaze, and may be a little goofy with emerging sea creatures and hoop-skirted ladies. In addition, my mom was "devoted" to Mary as a baby and was only allowed to wear the color blue for the first seven years of her life. Blue was not just a color; it was "Blessed Mother blue". For me, the color carried the connotation of Mary and her suffering. My initial artistic response was in glass. I heat formed layers of colored sheet glass to resemble the skin of a whale. I chose the whale because it is a wondrous benign beast that moves between continents and bears the burden of being a resource and a victim of humans. As I researched, the stranding of whales on beaches, the notion of running aground, making a colossal and sorrowful mess became a unique metaphor for apartheid, and the constancy of humanity's cross-like burdens. The glass pieces were then etched with imagery using a printmaking like process. The imagery included drawings of whales and delft patterns. The collection of five pieces has a somber tone. It is a body of work about brokenness. I call it *Beached*.

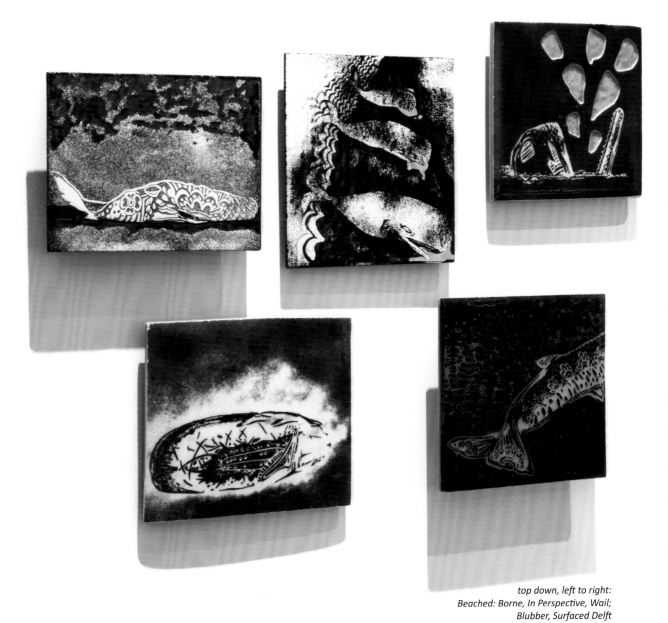

Borne

The dead whale is etched into the glass as an extricable part of the landscape.

In Perspective

The repeating of whales drooling gold lustre down the shoreline could be seen as a metaphor for our (humanity's) inability to stop the greed that causes the demise of others.

Wail

In this piece, with a similar skin-like quality to the glass, the whale is emerging, with mouth open. This piece was inspired by our time with the poet Zenzile Khoisan who was a member of the Truth and Reconciliation Commission because of his passion and conviction for healing and justice.

Blubber

This whale-skin like piece is etched with a stranded sperm whale. The emphasis is on the open mouth, communicating the condition to whomever is in front.

Surfaced Delft

This work is post-colonial in tone, with the flopped whale's tail emerging from the glass in a delft pattern.

top down, left to right:
Beached: Borne, In Perspective, Wail;
Blubber, Surfaced Delft

Deléne Human
South Africa

My art generally deals with the theme of resurrection, that is, life after death. Not only through subject matter but also through medium, technique and site, I attempt to portray how it is possible to bring something that was thought to be dead once (mostly symbolically and mythologically) back to life. With my current graduate research paper titled: *The fusion of horisons: Interpreting the archetype of the resurrection myth in contemporary visual art*, I thought that traveling through South Africa with fellow artists, African and American, I would be able to gain more insight into this topic.

Instead I gained insight into the resurrection of a country. In addition to the five Rs considered by our group of artists (Remembrance, Resistance, Reconciliation, Representation and Re-Visioning) as they are found in South Africa, I added the concept of Resurrection: living in a country after there was thought to be no hope—or life—left.

The R5: Visual Arts Seminar and Studio in South Africa residency, has made me painfully aware of the situation in which I find myself, as a white female African artist. My identity has ever since the seminar been in constant search of an anchor. The search for belonging has ever since been in the foreground of my art making. Even though I am African, I am also white. These two concepts do not usually go together. Even though I thought I knew my country, its history and its people, together with the group of artists, I came to the realisation that I know nothing. Growing up in a post-apartheid democracy led me to believe that we simply live in a country filled with hatred, blame and regret. Yet I slowly realised that all every South African really wants is peace, love, and hope. Our exhibition titled *Between the Shadow and the Light* beautifully summarizes the emotions evoked during time we were together.

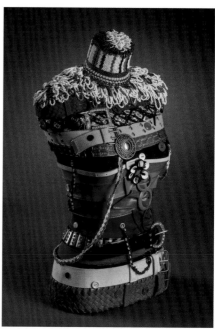

Hunger Belts

Double Negative series

These works are part of a larger series of drawings and negatives of photographs that I took while we visited the two

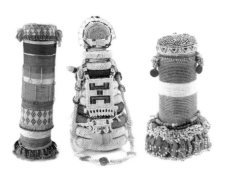

left: Mamaila Mgobeni, Vanyankwavi (sangoma's child figure), Tsonga-Shangaan, c. 1970 © Courtesy of Johannesburg Art Gallery (used with permission); center & right: Artists Unrecorded, Umndwana (child figure), Ndebele, mid-20th c. and N'wana (child figure), Ovambo, late 19th/early 20th c. © Courtesy of Johannesburg Art Gallery, both on long-term loan from the Brenthurst Collection (used with permission)

townships in Cape Town. I have inverted the images to create the black and white works. The title *Double Negative* indicates not only the negative of the photograph that I have used, but also the negative setting/feeling that the image creates. As I mentioned in our last group discussion while we were all together in South Africa, even though these township images are "ugly", there is something aesthetically pleasing about them that really draws me in. I feel the theme of "between the shadow and the light" is very fitting here. The contrast between the light and darkness, positive and negative in the everyday lives of many South African families becomes very evident throughout these images. I have also incorporated the use of the "smoke drawing" technique which we encountered in Diane Victor's work.

Hunger Belts – The Rainbow's Hope is a very complex work that incorporates many concepts and aspects of South African life. On the one hand, this work deals with my identity as a white, female, Afrikaans-speaking woman and how my Western heritage influences my identity as an "African". On the other hand, this work deals with the whole South African nation and each of our individual "hungers"—things we hope for, things we wish to change, things in

continued on page 131

Double Negative Series

Jackie Karuti
Kenya

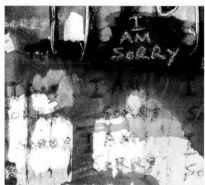

This work is an exploration of the complex ways in which people develop nostalgia for histories that could be considered illegitimate. It tells the story of a white South African male convicted for racial crimes just two years after South Africa's much-awaited independence. It challenges how we look at the human experience in times of grief and suffering regardless of who or what we identify as and also how we deal with the truth, forgiveness, and reconciliation. I've always been fascinated by words and their healing or destructive powers. It felt right to include them in this work in the form of letters addressed to a person of unknown identity who would hopefully grant forgiveness to an anguished soul. While highlighting subjects of remorse, repentance, and justice, it looks at the idea of healing as a process and the possibility of starting life afresh with a clean slate.

Stefaans' Letters

Stefaans Coetzee was only 18 when he detonated one of two bombs that shook the small town of Worcester in the Western Cape. He and three others targeted Shoprite and a pharmacy on Christmas Eve 1996 in the Worcester Mall barely two years after South Africa had gained independence and put an end to apartheid. They targeted stores at which blacks and coloreds shopped. Coetzee told his victims he had specifically chosen Christmas Eve as he wanted to kill as many people as possible. "I knew many people would rush to the shops for last-minute shopping and I knew it was a day when everyone would be happy, looking forward to celebrating Christmas. When I went home I was disappointed that so few people had died. I immediately started building another bomb." he said. Coetzee, Nicolaas Barnard, Abraham Myburgh, and Johannes van der Westhuizen were arrested shortly after the bombings. In 2010 they were among 149 prisoners who were recommended for presidential pardons.

I was introduced to Daniel Stephanus Coetzee (Stefaans) when a story was sent to all R5 participants to read in preparation for our time in South Africa. Over the next two weeks we spent in South Africa, I came to understand the power of forgiveness especially based on the impact the Truth and Reconciliation Commission (TRC) had. As I wondered what to base my final

artwork on, I remembered Stefaans' story and how he pleaded with authorities over the years so that they would allow him to meet or write to his victims in order to ask for their forgiveness.

This painting is a depiction of what I imagine Stefaans' life behind bars was like, tortured by his actions and yearning for forgiveness. I chose to do them in nine individual pieces in order to recreate prison windows. The implied letters are addressed to no one in particular because he did not know his victims personally. A lone hand in the middle stretches out as if trying to reach out or asking for permission to say something. The one piece without any writings symbolizes the beginning of life with a clean slate for Stefaans after he confessed and pleaded for forgiveness. Many years later some of the victims and even the victims' relatives finally agreed to meet with him and some even forgave him.

The following is an edited version of an actual letter he wrote while in prison to the victims of the Worcester Bombing.

Dear Victims, Community and My family, Since early childhood I battled to find my space in the sun. Life threw me

continued on page 131

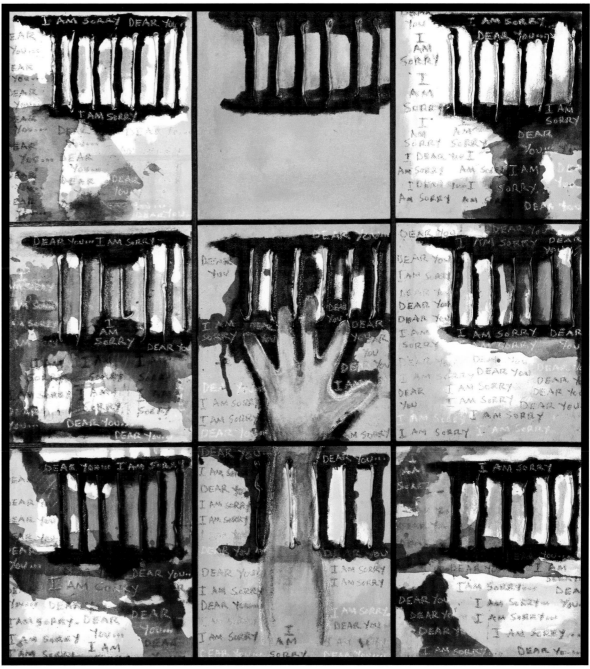

Stefaans' Letters

Keatlaretse Kate Kwati

in collaboration with Rachel Hostetter Smith

Botswana

The R5 Seminar offered me a chance to go back to South Africa after leaving the country about six years earlier when I was there as a student at Michaelis School of Fine Art at the University of Cape Town. The seminar offered much more than what I had learned as a student, as I now had an opportunity to interact with a lot of people who brought change to the face of apartheid. I knew stories which I heard in lecture rooms, radio, and television. I now had the opportunity to hear the stories from the people who came face to face with apartheid, and in some cases, had been victims. Issues of race, inequality, gender, xenophobia, death, and politics as well as social ills are still the subject matter for many South African artists, political figures, and church leaders as well as the ordinary man.

Even though I had background in what is happening there, most of my recent experiences posed a lot of questions for me. Coming from Botswana, a country sharing a border with South Africa, I have always counted myself lucky that I was not born there, based on the stories I had heard. I now realize how much South African events have affected me. I live in Botswana lacking a lot as an individual, and realize how much South Africans have despite the afflictions they lived with. They have the best of everything. The best schools and education system, health services, infrastructure, and a lot more compared to a lot of African countries. South Africa is more developed and experienced due to the fact that they were never too comfortable and had to strive to be known and heard.

This has helped me to re-invent myself as an artist. I am a conceptual artist and art teacher. Like a lot of South African artists, I now strive to use my art as a tool to communicate my experiences. My subject matter references my personal experiences as a woman and the experiences of other women around me. And I am now working more on projects that are meant to educate and reach out to the masses based on whatever situations I come across.

As an art teacher, I teach my students to challenge themselves and use their experiences when making works of art. I believe that as an African, the "other" lives within me, and it is the phenomenon of the "other" which I must address. I have injected purpose into my art-making. Through the R5 seminar, I have learnt that every part of the world has its unique story to tell. Like Father Michael Lapsley (Institute for Healing of Memories, Cape Town) said, our healing power is in telling our stories and experiences. Our misfortunes are not always God's will and accepting one's misfortune will bring one victory.

Ties That Bind: The Fabric of Our Being

These are video stills from a performance piece which took place on the 1st of July 2013 at Thapong Visual Arts Centre in Gaborone, Botswana. The piece references conceptual portraits of African women. It was more of a social commentary that addresses our experiences through my eyes. I have always seen the African as a "self-proclaimed" victim. More often, we find ourselves in situations where we are pitied and waiting helplessly to be helped out. Personally, I believe that women's issues are universal. We experience similar psychological and physical wounds, scars, pain, wishes, and emotions.

I have used symbolism to communicate these issues. The tied up body, the struggle to break free from the bond by mostly relying on oneself; cutting, sewing, and the like were meant to demonstrate emotions as well as circumstances. It also shows that it is okay for a woman to get herself out of certain situations. Every muscle movement, every thread and stitch were functional. The stitches are meant to demonstrate healing, binding, comforting, and bringing together. But the cutting shows the need for us to gain freedom because not giving up leads to victory. I have always believed in a woman who doesn't crush but uses her experiences to uplift herself and the next woman.

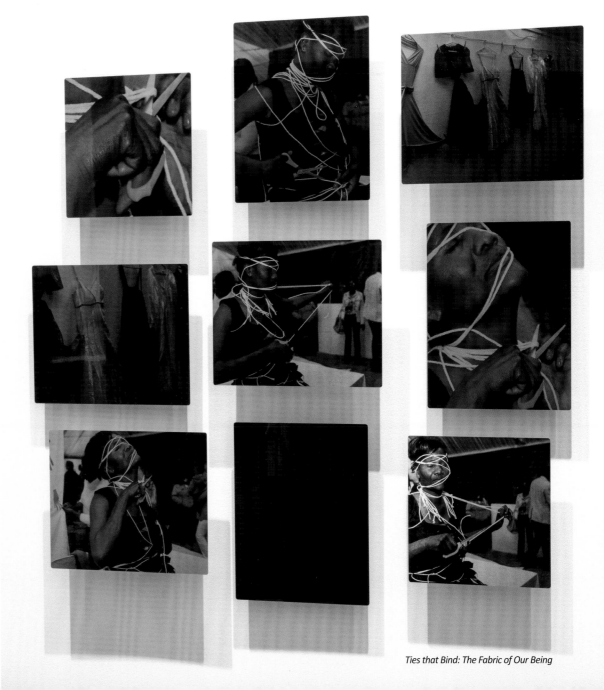

Ties that Bind: The Fabric of Our Being

Xolile Mazibuko
South Africa

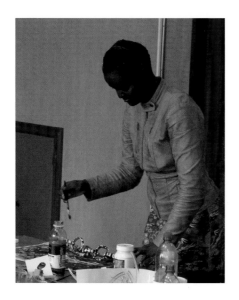

A Woman's Day in South Africa is a painting about the history of the identity document in South Africa and the way pass laws controlled the lives of South Africans and the resistance against them.

According to the African Studies Center website at Michigan State University:

Pass laws were designed to control the movement of Africans under apartheid. These laws evolved from regulations imposed by the Dutch and British in the 18th and 19th-century slave economy of the Cape Colony. In the 19th century, new pass laws were enacted for the purpose of ensuring a reliable supply of cheap, docile African labor for the gold and diamond mines. In 1952, the government enacted an even more rigid law that required all African males over the age of 16 to carry a "reference book" (replacing the previous passbook) containing personal information and employment history.

Africans often were compelled to violate the pass laws to find work to support their families, so harassment, fines, and arrests under the pass laws were a constant threat to many urban Africans. Protest against these humiliating laws fueled the anti-apartheid struggle—from the Defiance Campaign (1952-54), the massive women's protest in Pretoria (1956), to burning of passes at the police station in Sharpeville where 69 protesters were massacred (1960). In the 1970s and 1980s, many Africans found in violation of pass laws were stripped of citizenship and deported to poverty-stricken rural "homelands." By the time the increasingly expensive and ineffective pass laws were repealed in 1986, they had led to more than 17 million arrests.

*Xolile Mazibuko with Deléne Human
at the Apartheid Museum*

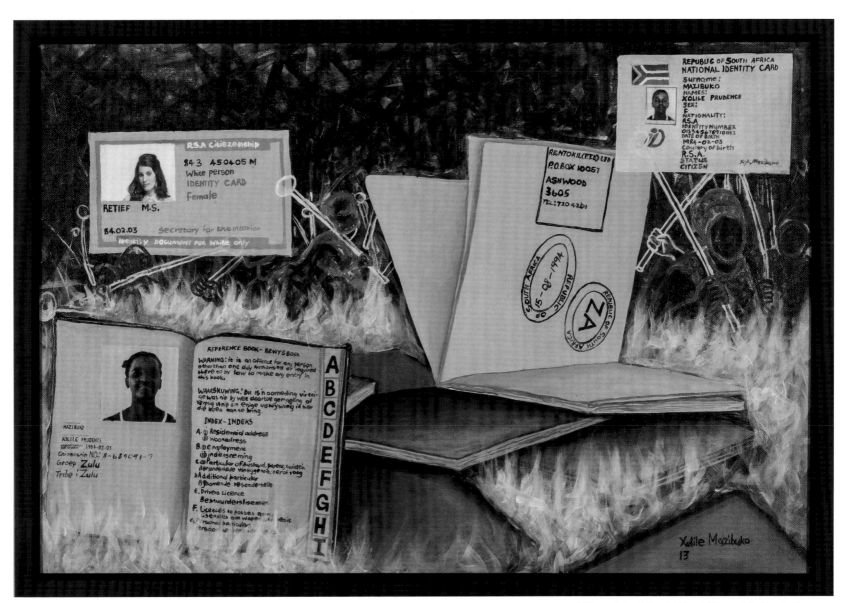

A Woman's Day in South Africa: A History of the Identity Document

Valentine Mettle
Nigeria/South Africa

My work takes a critical view of social, political, and cultural issues, referencing South African history. It explores the varying relationships between culture, environment, and fine art. Having engaged subjects like civil rights movements and nature in general, my works produce familiar visual signs by arranging them into conceptual layered forms.

I also take nature seriously. We tend to take nature for granted but it reveals a lot of interesting things. We are surrounded by it, protected by it, and could be destroyed by it. This seeming paradox is what interests me in nature. I see in nature complex images, spiritual fulfillment, and peaceful creative anchorage. Nature colors my perception of people, events, and places and inspires me as I dialogue with it. The colors I see during this dialogue are reflected in my works.

I believe it is the duty of the artist to record events that affect society in whatever medium the artist uses. In this way, the artist becomes more socially relevant. My specialty is textile designs and printmaking, but I believe an artist worth his salt should not be restricted to one medium so I also work in other mediums like painting, digital and mixed media.

The language of my work mirrors South Africa and South Africans, socially, politically, and religiously. This has really opened my eyes and thoughts toward life and nature in general. In the work for this exhibit, I paid great attention to colors. They represent all of the elements we find in the universe—good, evil, sadness, and happiness, and their attendant features. As Goethe said, Nature is the sole ARTIST.

My triptych *From Struggle to Victory* is a tribute to South Africans' struggle for 350 years to gain equality and justice. The South African freedom struggle reveals the defeats and victories of the people in their

continued on page 132

 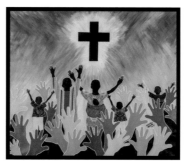 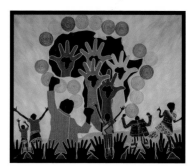

left to right: From Struggle to Victory: Resistance, Petition, Release

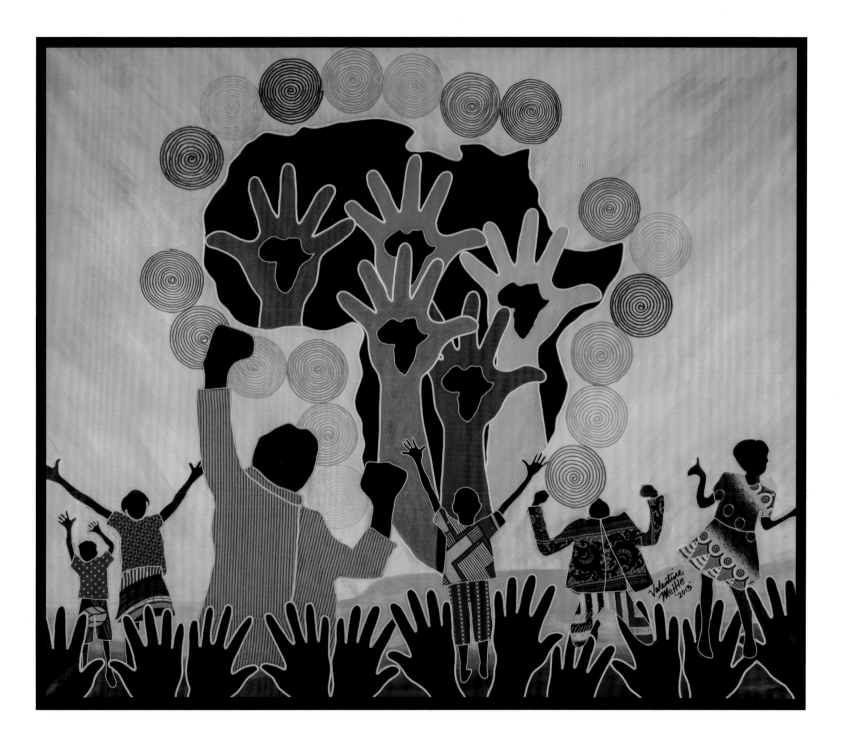

Phumlani Mtabe
South Africa

There is a saying, "aspire to inspire before you expire". I have gained a lot of inspiration during the R5 seminar. Learning more about South African history and its phenomena has inspired me in creating and constructing these works of art. The representation of social and political life in South Africa is the main source of my inspiration which we encountered in the museums and art galleries. My favourite artist we met is Diane Victor whose work reflects these concerns through powerful and creative imagery and techniques.

The Hole Truth is a small cardboard coffin representing the trap or hole that led to death for many of those who stood for the truth. It is a tribute to those who died in the struggle against apartheid. It specifically refers to the event that took place on 16 June 1976 known as the Soweto Uprising when school children rose up in protest of the requirement that they be taught in Afrikaans instead of their own languages. Many were killed. But this event is seen as a turning point in the struggle against apartheid.

My work *Is Design a Solution?* was inspired by the forced removals acts and the segregation of people by race such as what occurred in District 6 of Cape Town. This work poses the question: Does such "design" bring a solution or does it perpetuate the cause? This work reflects my new view of the township and my hope for change in a country where many of us "natives" are still very poor while others are not. Education, housing, EQUALITY and our identity as a nation— those are the biggest issues that we face as South Africans, and design can be used to redeem them— DESIGNING THE HOPE OF THE FUTURE.

Is Design a Solution?

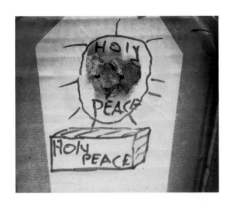

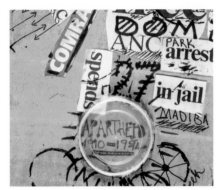

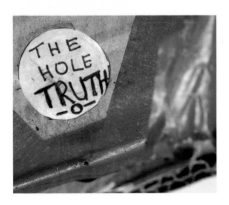

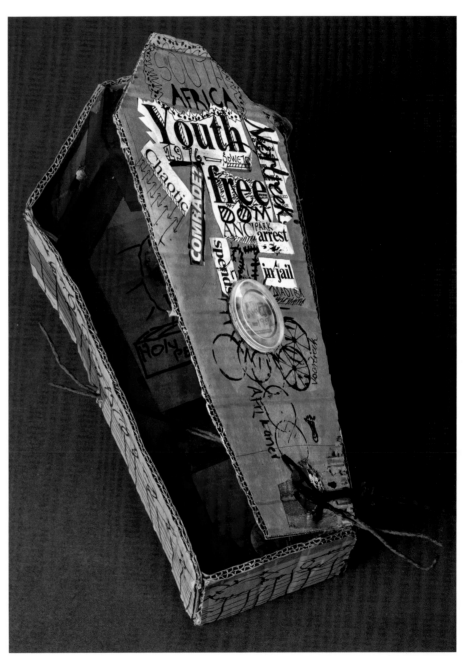

The Hole Truth

Petros Mwenga
Zimbabwe/South Africa

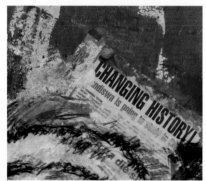

My artworks in this exhibit represent the five Rs we investigated in the seminar: remembrance, resistance, reconciliation, representation, and re-visioning. Without all of these there will be no peace or unity. My sources of inspiration include the eternal burning flame of democracy at the Constitutional Courts in Johannesburg, the Apartheid Museum, and the Portuguese saying *a luta continua* which means "the struggle continues". To God be the glory.

My work titled *Protea* represents the aesthetic harmony of all cultures and the country flowering as a free and unified nation. It is all about peace and unity between different races in South Africa. The protea is an indigenous South African flower. For the country to flower as a nation there should be oneness so "black" and "white" fall away to show the *need* for oneness. It reflects the wisdom of the saying "united we stand, divided we fall." It also represents the flame of freedom and the different colours in one nation.

Man in the News is a collage about Nelson Mandela as an outstanding individual black president who was selfless. The charcoal lines represent freedom and black people, and pictures, newspaper cuttings depict other races. I created this painting as a collage where even the technique reinforces the idea of sticking different religions, cultures, and races together to form unity (and one artwork) as Mandela wished. Different colours, one nation. Mandela articulated these ideas well in his speech when he was brought to trial at Rivonia in 1964:

> We believe that South Africa belongs to all the people who live in it, and not to one group, be

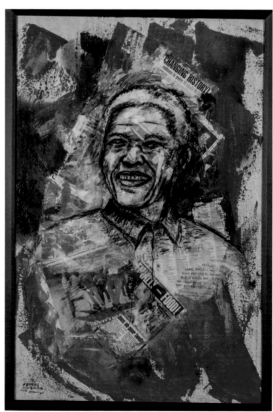

Man in the News

74

it black or white....Political division, based on colour, is entirely artificial and, when it disappears, so will the domination of one colour group by another. The ANC has spent half a century fighting against racialism. When it triumphs it will not change that policy.

This then is what the ANC is fighting. Their struggle is a truly national one. It is a struggle of the African people, inspired by their own suffering and their own experience. It is a struggle for the right to live.

During my lifetime I have dedicated myself to this struggle of the African people. I have fought against white domination, and I have fought against black domination. I have cherished the ideal of a democratic and free society in which all persons live together in harmony and with equal opportunities. It is an ideal which I hope to live for and to achieve. But if needs be, it is an ideal for which I am prepared to die.

right: Protea

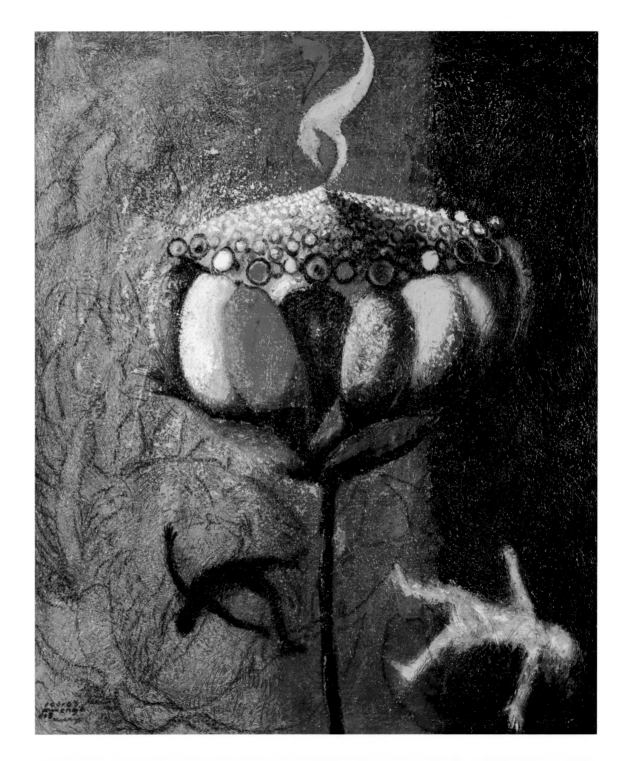

Charles Nkomo
Zimbabwe/South Africa

Charles at the National Gallery in Cape Town and Charles' paint brushes in studio

Visiting various historical places like Robben Island and talking about the history of South African politics with Zenzile Khoisan who served on the South African Truth and Reconciliation Commission and Archbishop Desmond Tutu, a Nobel Peace Prize winner, during the R5 seminar impacted me greatly, leaving an indelible mark on my heart.

These places made me aware of the experiences of the black South Africans during the apartheid era and they seemed no different from the experiences of my own fore-fathers in Rhodesia during the reign of Ian Smith. The cruelties against the black miners, farm workers, factory workers, and domestic workers were no different. The wars fought sure were different and the methods used differed as well. However, all wanted freedom. But the outcome of South Africa's struggle for freedom was different. The leaders of South Africa who won the freedom handled their victory differently. Nelson Mandela forgave everyone, allowing peace and unity to reign, and he even relinquished power to the younger generation in contrast with South Africa's neighbour.

But despite the economic achievements in South Africa, its own people are still not well educated and only a tiny minority is technically skilled to run their own enterprises. The black majority is still living in abject poverty and the political leadership is getting wealthier as a result of corrupt tendencies. My paintings depict the squatter camps where the majority of South Africans live. They portray the squalid conditions and the miserable lives being led by the voting majority.

Moment by Moment was inspired by freedom and the dreams that the people of South Africa needed in the dark days, as they lived moment by moment.

Reflections addresses the first removal of Africans living in District 6 (a residential area of Cape Town where people of different backgrounds and races mixed freely) in 1901 to the "native areas" after an outbreak of bubonic plague. The forced removal of the residents of this multi-cultural, multi-racial neighbourhood was fully undertaken to make way for a whites-only development beginning in 1966.

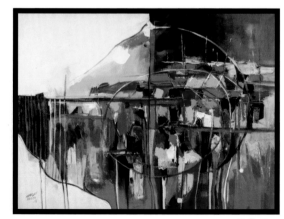

Reflections

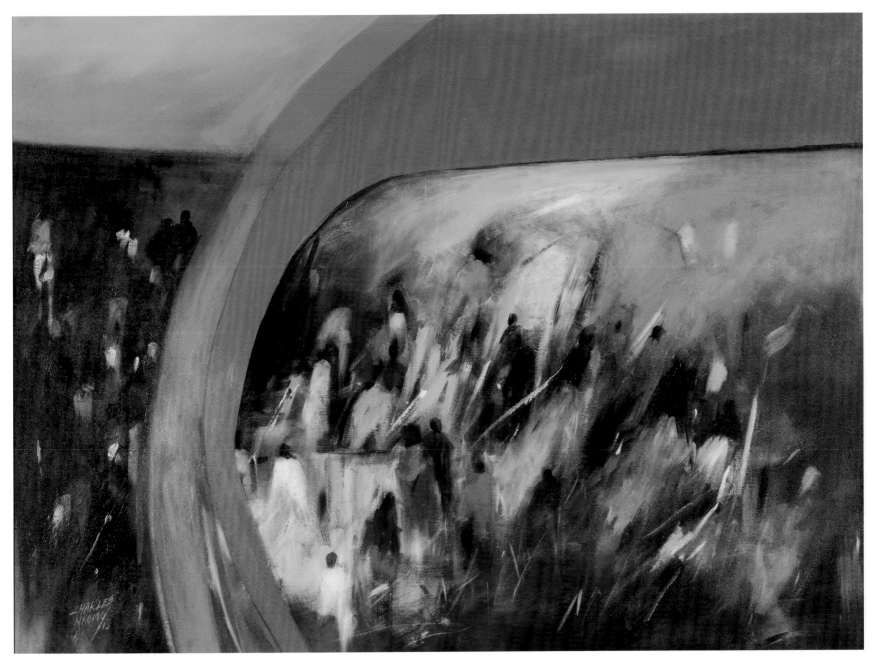

Moment by Moment

Magdel van Rooyen
South Africa

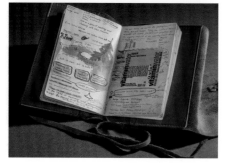

Visual Diary: R5 Journal

Thinking back on the R5 seminar I remember the time as being incredibly rich but not very easy. What was especially difficult was looking into the mirror of the country of my birth and seeing all the injustice and hurt that was committed.

In the months that followed I deciphered the emotions uncovered in those two weeks. It can be summarized as loss and hope. A sense of loss for all of the pain that was suffered and all of the inhumane deeds that were committed, but also a loss of the good that existed. In addition to that and on a personal level there is also a loss for the Afrikaner traditions for which it seems there is no place anymore. And then there is hope. Seeing and experiencing on a daily level the reconciliation and the rebuilding of a nation. So for me the present day South Africa resembles a construction site. There is the breaking down of the good and the bad and the hope residing in the rebuilding. The process of rebuilding takes time and unfortunately there are negatives which sometimes feel as if it will diminish any positivity. My painting *Constructing Hope* is done on a rusted steel plate that creates the tension between what is present and the destruction thereof. With this I attempt to convey the tension between the loss and the hope I experience. We have to choose hope on a daily basis, remember the loss, and laugh about the differences while constantly contributing to the construction of our future.

Constructing Hope

In Pretoria and Johannesburg there is a lot of construction going on at the moment with the promise of a new transport system. This is a great prospect but the result of constructing new roads is sitting in traffic or being diverted and sitting in traffic elsewhere. And while sitting in the traffic one tries to calm oneself down because there is hope that in a few months (or a year) the roads will be better and the traffic will be less. But one also has to suppress a thought like, "I wonder how much corruption was there when they assigned the tender for the upgrade of this road," or "Will this road be built properly or will it just be a system that does not really work or a system that is not maintained and will become a white elephant with potholes?," or "Maybe they will make us pay toll for these roads, too."

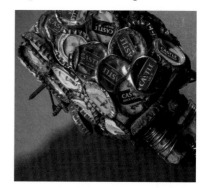

Rusted Protea

This paradox of hope and loss is what I wanted to express. In the months after the R5 seminar those were the feelings that remained;

continued on page 133

78

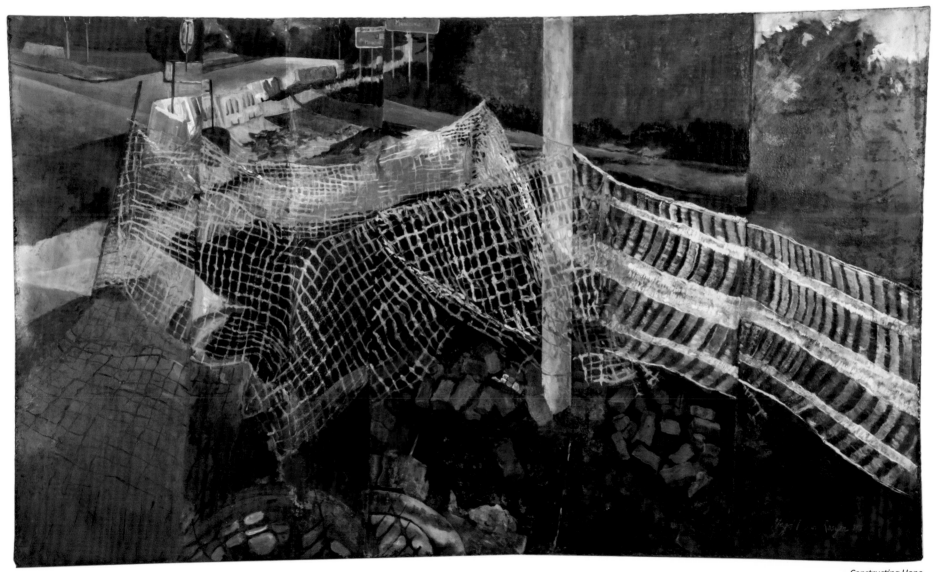

Constructing Hope

Allen Sibanda
Zimbabwe

My experience in South Africa was very enriching and also very disturbing to my spirit. I tend to approach things from a point of view of asking, observing, listening. Collecting and depositing it in my heart. South Africa stretched my thinking to a breaking point. I had to learn to process fast because each day had its own surprises. I remember asking myself a lot of questions especially concerning their history. I remember thinking after walking into spaces housing their history how I could be that affected? How much more then the people that had lived during that time? You try and cross to the other side to understand, to account for the actions taken. What kind of a spirit was in those that planned and set up a system so oppressive? What blinded them not to see that the other peoples were as human as themselves? Coming from a place where some parts of our history are not up for discussion, I appreciated that they chose to deal with their history and up to now still continue to do so.

I know a place (still mending)

In this work the mending begins on the inside but the completion of the mending process is visible on the outside. The mere passage of time does not bring about wholeness; the one who has been hurt has to take the initiative to will to walk again. You are taking new steps along a new path that will break forth to a place of wholeness. This is not easy because it involves learning to trust again. I believe God has not left us alone but has promised to walk with humanity. Isaiah 43:2 assures, "When you pass through the waters, I will be with you; and when you pass through the rivers, they will not sweep over you. When you walk through the fire, you will not be burned; the flames will not set you ablaze." (NIV) Only God knows the sensitivity of each issue, the parts that need patching up, how to patch them, what materials to use, and how long the patching process will take. I work with different mediums. My choice of medium is influenced by the subject at hand. For this work I chose to use a thread and the act of sewing to convey the passage of time, a sense of care, sensitivity, and delicate-ness which I believe reflects the components of the process of healing. The x-ray sheet material represents the process of healing which takes place—hidden—behind the scenes.

Scars will always remain

All wounds leave scars behind. Some are visible because the marks are in the open.

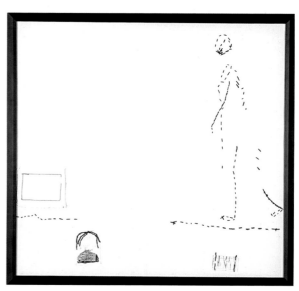

Scars will always remain

80

Some marks made are located on the inside. You can tell by the sound of the voice, the tilt of the head, in the manner a person carries himself or herself as they move through life that they may be carrying burdens on the inside caused by hurts in the past. The transparent material I chose to use in this work represents the unseen which is always there. We tend to focus more on the outside leaving the spirit unnourished. The patch represents the unseen marks which are hidden to the viewer but are nevertheless present. In this work the act of sewing is used to highlight those hidden marks.

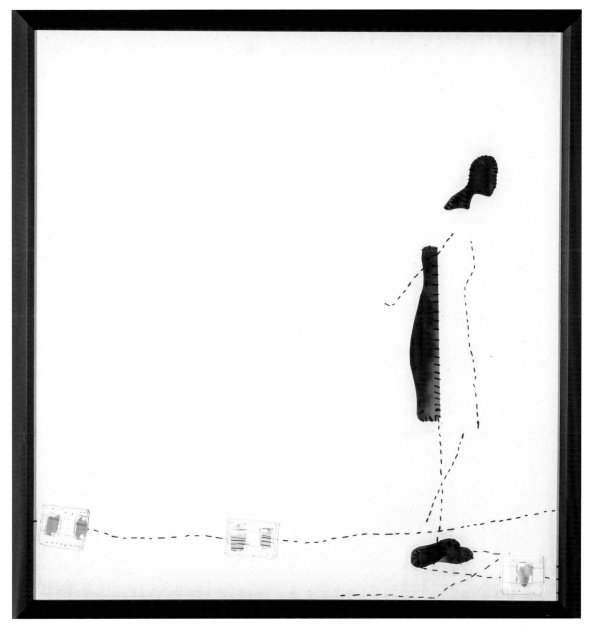

I know a place (still mending)

Katherine Sullivan
United States

R5 visits to South African museums, galleries, monuments, and places important to the anti-apartheid struggle were predictably powerful. However, numerous visits with South African artists, clergy, and activists were especially illuminating. Similarly, the "book list" of South African authors provided by R5 leaders was enormously impactful in providing in-depth accounts of historical and contemporary South Africa. This background was critical in developing a nuanced view.

Making artwork about a place other than one's "home culture" can be daunting. As an artist who is decidedly "other" to South African culture, I had to balance genuine engagement with what I had experienced with my status as a non-South African. Questions about what I could and could not appropriate or judge were tantamount throughout my studio process.

The R5 South African experience has helped me view American culture through a more critical lens. The stark divisions in South African society—between rich and poor, black and white, men and women—are not unusual. However, the outspoken acknowledgement on the part of South African institutions and individuals about how those divisions were created, fostered, and perpetuated seems unique. This acknowledgement is also understood as critical to how the country seeks to heal these divisions. This openness continues to charge how I see similar divides in the United States and to how I view my role as a painter. In particular, I've begun to think more deliberately about oil painting and the medium's political and cultural implications. The medium itself is inherently imbued with historical and geographic associations. For the first time, I've tried to address those directly in my post-R5 studio process.

It will take much longer than a year to process the extraordinary introduction to South Africa that R5

Purple Shall Govern II, Interrupted Atman

provided. I feel that I am merely at the beginning of a long and sustained engagement with the country and its culture.

Chronicle I; My Traitor's Heart

Inspired by Rian Malan's 1990 autobiographical book *My Traitor's Heart*, and painted in a style reminiscent of Dutch "Golden Age" painting, which reached its zenith in the Netherlands in the mid-17th century just as the first Dutch settlements appeared in South Africa, *Chronicle I* is a response to the enigma that contemporary South Africa presents.

While conceived as an abstract image, the painting is composed of symbolic representations of three dominant ethnic groups that comprise today's South Africa. The marigold garlands represent the Indian population, largely brought to South Africa as indentured workers in the 19th and early 20th centuries. The blue and white springbok-patterned fabric borrows its palette from the 16th and 17th century Delftware that would have been familiar to both Afrikaner and Boer settlers of the time. The springbok, an antelope native to south-western Africa, has held various symbolic roles in the country's history, and was especially prevalent during the apartheid era, when it was used as an emblem and logo by the minority white government. The predominant brown, black, and red form attempts to suggest the symbolical body

continued on page 133

Chronicle I; My Traitor's Heart

Larry Thompson
United States

The R5 Visual Arts Seminar in South Africa continues to be a haunting experience. As an artist who deals with the idea of contrast on multiple levels within my own studio practice, be it the contrast of light and dark, space and flatness, and the tangible and abstract, the contrast that is South Africa is a vivid example of the tension created when competing forces come together. Balance and contradiction to create a visual tension has long been the wording entrenched in my standard artist's statement for any random show. But the days in South Africa were like walking into that visual tension and being surrounded by it in four dimensions. Growing out of the experience were conversations, both internal and external, about the extremes of that contrast that always circled back to the center, and at the center of it all was humanness. We are all human but we still have so much work to do to see that across the contrasts.

Barriers Still

As an artist I am often drawn to imagery that involves repetitive patterns and contrast. As I walked around different locations throughout South Africa one image that I saw constantly was razor wire. The image immediately became very metaphorical for me— the idea of a barrier to keep something in, *and* keep something out, and to do so with a menacing threat of violence if one dared try to breach the barrier. The wires were everywhere, from the walls of a church to just about every personal dwelling across all levels of socio-economic status. Often these wires were above eye level so I found myself constantly looking up at this pattern of ellipses and triangles with the blue sky beyond. I kept chasing this beautiful blue sky, this peaceful space always beckoning, but inevitably there was a sharp barrier cutting off the path to that place. *Barriers Still* acknowledges that there are places of peace and beauty, and that collectively we have come a long way toward removing some of our historical barriers, but barriers still exist and we still have a way to go to reach that blue sky.

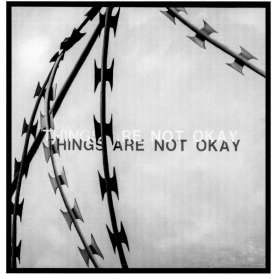

Barriers Still

An Intentional Intersection

One day, just outside the entrance to the District Six Museum in Cape Town, South Africa I met Henry. Henry was leaning up against the wall minding his own business. As I tend to do when in a place for the first time, I had camera in tow and was snapping pictures of anything and everything I found interesting. I found Henry interesting but out of politeness didn't think it appropriate to take Henry's picture as if he was some interesting object. Henry invited me to take his picture because, as he said, "I'm a human, too." Henry is a human, as we all are. As I spent more and more time with my roommate for the seminar, Valentine Babs Ayi Mettle, the conversations we had were less and less about the differences in our respective countries or our experiences as individuals with skin of different hues. Instead, the conversations were increasingly about family, relationships, and careers. Two very different people from two very different places collided in *An Intentional Intersection* in South Africa, but it is our humanness that connects us forever.

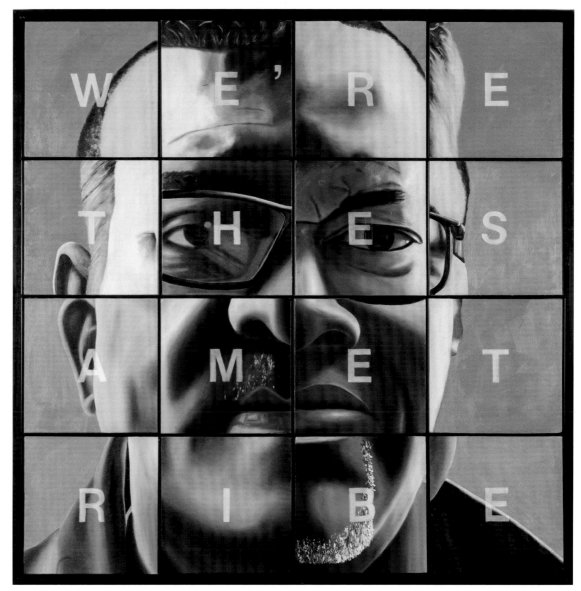

Jo-Ann VanReeuwyk
Canada/United States

I've fallen in love with Archbishop Desmond Tutu. I am not alone. Those who live in South Africa lovingly call him "the Arch." They delight in him. I've started to carry a little book around with me called *An African Prayer Book* (1995) edited by the Archbishop.

In it he states, "...we are made to live in a delicate network of interdependence with one another, with God and with the rest of God's creation. We say in African idiom: 'A person is a person through another person.'" (xiv) He commonly refers to this interdependence using one of his favorite terms, the Zulu word *ubuntu*. He tells us "...we are a remarkable paradox—the finite made for the infinite, the time-bound with a nostalgia for the transcendent, the eternal. It has been said that we each have in us a God-shaped space and only God can fill it. Our natural milieu is the divine..." (xvi)

I've also started to carry around with me a small, black stone. I've been prone to carry around stones for years, but in their recent book *The Book of Forgiving* (2014) Desmond Tutu and his daughter Mpho Tutu suggest a number of exercises to foster reflection and perhaps even forgiveness. One exercise is to carry a small stone. Now that I have met the Archbishop I cannot separate my natural tendency to pick up a stone from the notion of utter forgiveness.

This is the most significant concept that I've taken "home" with me: the incredible evidence of a nation that has achieved at least a level of forgiveness. The devastating years of apartheid should have, in my estimation, eliminated all hope, all forgiveness, and inspired only retaliation. But the rainbow nation refused to succumb to that devastation and horrific abuse. What lessons we can learn from their example.

When our group met with the Archbishop in his small office he extended incredible graciousness to us, complete strangers. He immediately identified with those in our group who live all over Africa, comfortably moving from one language to another. But that is not to say that those of us from North America felt unwelcome. Not in the least. His laughter enveloped, included, and pulled each one of us in. Archbishop Tutu is truly a marvelous man filled with His spirit, speaking the words of Christ. And the wisdom of those words he directed to his own country South Africa, particularly about the need for forgiveness, still speak to all of us today.

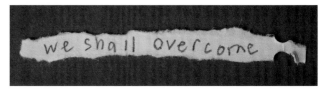

continued on page 134

right: Tyre

Kimberly Vrudny
United States

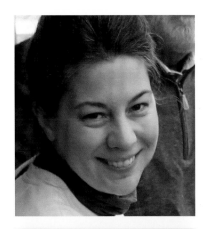

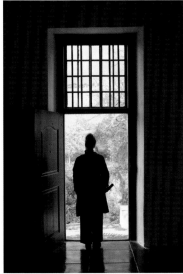

Traveling to South Africa has been revolutionary in terms of my own theological and artistic development. The colonial occupation of the country in modern times, as well as the country's struggle against apartheid, illuminates the situation in which Jesus lived during the first century—in Palestine under Roman occupation. Entering more deeply into an understanding of South African techniques of nonviolent resistance to oppression informs an understanding of Jesus' teachings, explaining, too, why he was a threat to power and why he was killed. For example, in Jesus' day, when an overlord struck an underling openhandedly, the overlord was acknowledging the servant's equality. So Jesus cleverly advises, recognizing an oppressor's slap would be backhanded, "Turn the other cheek also." Jesus knew that to do so would disarm the opponent. It would force the perpetrator to recognize the humanity of the one he was assaulting. It was a strategy of resistance without resorting to violence. Examining the apartheid regime's methods of torture to put down revolt also provides insight into the conspiracy against Jesus—this rabbi who challenged both religious and secular authorities by speaking of another Kingdom, a community where God's good, beautiful, and just will is done *on earth, as it is in heaven.*" By such compelling preaching, he amassed a large following. Recognizing Rome was bloodthirsty for those suspected of treason, religious authorities conspired to hand him over, in effect, to save the Jewish nation and its Temple—a strategy which was effective, at least for another forty years, or so. The same lesson was learned too well nearly 2,000 years later by those who were planning South Africa's resistance when they, like Jesus, were betrayed—some even by friends: Stephen Biko and the list of South African martyrs, among them, as well as those who were unjustly imprisoned—Nelson Mandela, Walter Sisulu, among many others. I am grateful to the R5 seminar for contributing to these and many more discoveries, which will inform my work for many years to come.

Beauty's Vineyard

Panel 1: *Theology—Haut Bay, South Africa* (top left)
"In the beginning when God created the heavens and the earth, the earth was a formless void and darkness covered the face of the deep, while a wind from God swept over the face of the waters. Then God said, 'Let there be light'; and there was light. And God saw that the light was good . . ." (Genesis 1:1-4). When God brings being into being out of Being, God's Being, which is True, Good, and Beautiful, is evident in the very nature and structure of the universe, and is expressed to some degree in all that exists. I am attempting to reimagine the Christian tradition in such a way that we are empowered to work for the restoration of Eden, that ideal community of peaceful, just, and loving relationships lost so long ago, when

humans first walked the earth and first sensed that they had violated what is good, right, and decent. It is that idyll that is represented in this image of Haut Bay at sunset. When God brings being into being out of Being, creation is essentially good, true, and beautiful. This goodness is built into the very nature of the universe, and is expressed through all that exists. South Africa's breathtaking landscape is a reminder of the original beauty of the universe and God's giftedness to us in creation.

Panel 2: *Anthropology—"Barcelona," Guguletu, South Africa* (top right)

"So God created humankind in his image, in the image of God he created them; male and female he created them. . . ." (Genesis 1:27; 3:13). Whereas ethical living and compassionate being are attractive to us, alluring our imaginations, drawing us to participate more fully and more deeply in what it really is to Be, our nature, which is free, inevitably violates the Creator's will for us, which is to maintain the good, beautiful, and true relations of creatures to God, and of creatures to creatures. Our freedom, when we choose against what is good, true, and beautiful, wreaks havoc personally, resulting in minds, wills, and hearts that are easily lured away from what is right; relationally, resulting in connections between people that are marked by brokenness and woundedness; and structurally, resulting in systems that oppress, exploit, and harm entire societies. Every nation on earth has its own unique story, its own apartheids for which to make restitution. The existence of townships outside of every town, large and small, throughout South Africa bears

continued on page 134

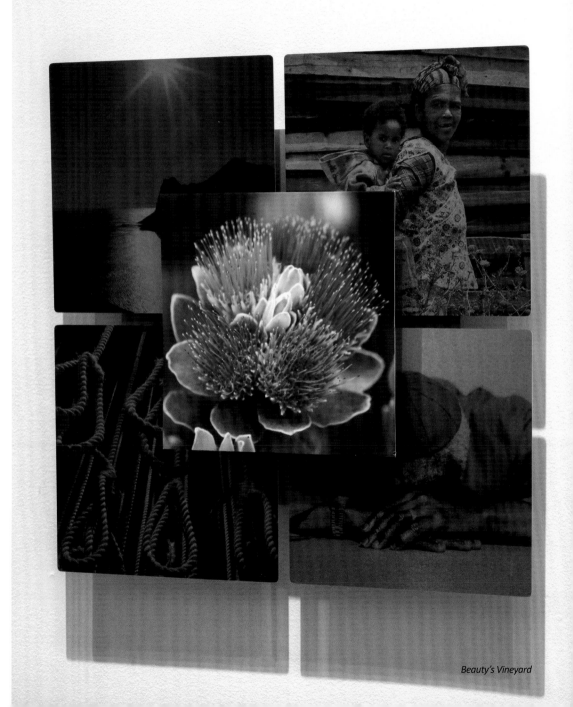

Beauty's Vineyard

A Collaboration between:

Michelle Westmark-Wingard United States
& Magdel van Rooyen South Africa

FROM MY SIDE OF THE WORLD
by Michelle Westmark-Wingard & Magdel van Rooyen

Every history has more than one perspective and every conversation more than one voice. When we think of the landscapes around the world where wars, political unrest and social injustice have taken place, for many, time has healed the landscape but perhaps not the people.

In my home state of Minnesota, it took 150 years for the U.S. Dakota War between the settlers and the Native Americans to be publicly reexamined. I've thought about my own culture through a somewhat different lens following the R5 trip. South Africa has been a powerful example of reconciliation and equality after apartheid and yet their country is struggling with how to remember and learn from the past in the midst of healing. As it turns out, to forgive and forget is not always the healthiest way to move forward. Desmond Tutu said,

> Forgiving is not forgetting; it is actually remembering—remembering and not using your right to hit back. It is a second chance for a new beginning. And the remembering part is particularly important. Especially if you don't want to repeat what happened.

Much of my work is about collaboration, visual conversation and the exploration of multiple viewpoints. My time in South Africa and the collaborative visual conversation that grew out of the experience, From *My Side of the World*, offered an interesting dialog on what it means for a culture to live in tension and heal from a complicated past.

—Michelle Westmark-Wingard

From My Side of the World
digital video projection

From *My Side of the World* is a collaborative visual conversation between Magdel van Rooyen in South Africa and myself in the United States. Over the course of six months, we have been posting photographic responses to each other's images in blog-form. These 38 photographs explore cultural similarities and differences, landscapes, and current events. The photographs range from showing the difference in landscapes and difference in climates to visually talking about the monuments to the U.S. Dakota War and ideas of cultural reconciliation and the illness and passing of Nelson Mandela. One of the most powerful aspects of this project has been being able to have a conversation in real time from opposite sides of the world through

Michelle Westmark Wingard
June 10, 2013 at 9:10am
near Green Point, South Africa
Time, reflection

Magdel van Rooyen
June 11, 2013 at 9:27pm
near Cape Town, South Africa
Shadows to move in

A Collaboration between:
Michelle Westmark-Wingard & Magdel van Rooyen continued

technology. Little did we know when we began this project that it would conclude with the news of Nelson Mandela's passing. It has been a profound experience to see the overwhelming influence Mandela has had on not only South Africa, but also the world.

—Michelle Westmark-Wingard

This project came about one evening when Michelle and I were discussing her camera project in Cape Town. We asked the question, "What if we pursued a visual conversation over the next few months? Perhaps as an experiment to showcase how our daily lives are similar and different, and if it will be affected by the seminar?" A small part of it served as therapy to have a place to voice a visual image that was triggered by the R5 journey, but which the people at home would not understand because they were not part of the R5 seminar. The easiest way to communicate this was on Facebook so that was our chosen medium. I enjoyed this project thoroughly. It made me more critical visually and I really liked the conversation that emerged with what was happening in Michelle's world.

—Magdel van Rooyen

Michelle Westmark Wingard
June 13, 2013 at 4:12pm
near Constantia, South Africa
Casting Shadows

Magdel van Rooyen
June 13, 2013 at 4:19pm
near Constantia, South Africa
Shadow under the cross

Michelle Westmark Wingard
December 24, 2013 at 3:46pm
near Minneapolis, Minnesota
Christmas Eve: frosty, merry and bright

Magdel van Rooyen
December 31, 2013 at 3:10pm
near Sinoville, South Africa
Ending 2013 in proper South African style: sunny, with a slight chance of afternoon showers

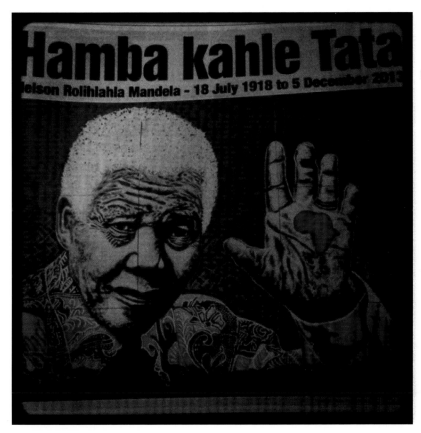

Magdel van Rooyen
December 10, 2013 at 8:20pm
near Elarduspark, South Africa
"Hamba kahle Tata"—Go well Father.
The headline on one of our newspapers.
Today the memorial service of Mandela.

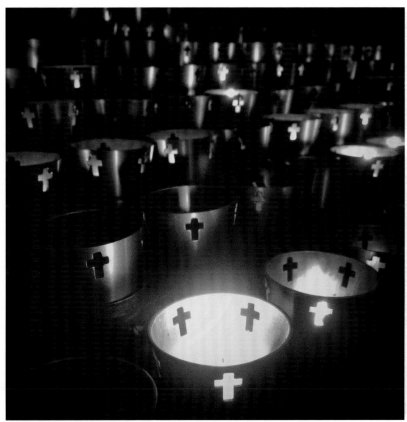

Michelle Westmark Wingard
December 14, 2013 at 6:15pm
in Saint Paul, Minnesota
Memorial service for Mandela today.
We lit a candle for him and for the legacy of
change and reconciliation he leaves behind.

A Collaboration among:

Margaret Allotey-Pappoe *Ghana/United States,*
Deléne Human *South Africa,*
& Jo-Ann VanReeuwyk *Canada/United States*

Home is where we expect safety and sanctuary. So many homes are fraught with danger—sometimes physical, at other times emotional and psychological. We inhabit our spaces expecting protection. Many of us receive the opposite.

Home is a place where we expect to extend hospitality. We place hope in these spaces. We hope to thrive. Many of us barely survive.

None-the-less home is where we continue to seek solace, comfort and safety. It is what we hope for. This is universal.

During our time together in South Africa, the three of us decided to each create a vessel depicting something of our own heritage and culture. We have called it *INHABIT: shantytown*.

—Margaret Allotey-Pappoe, Deléne Human, & Jo-Ann VanReeuwyk

INHABIT: shantytown

Awo (means Mother in the Ga dialect—Ga Adamgbe tribe from Ghana)
This vessel was designed to represent the human body, specifically the female human being with a long slender neck and large earrings. Traditional pots are essential objects in most African homes. They are used to store water, a precious commodity that life depends on. The pot symbolizes the nurturing and preservation of human life. It has often been said that a pot or vessel is like the womb of a woman who holds and preserves the life of her unborn child until she births the child. Similarly, all of us continue to hold on to our dreams, nurturing them, believing that at the right time something beautiful will be birthed.

The weaving technique was employed to intertwine both the weak and the strong. The metal signifies the resilience and sturdiness of the African people and paper, the fragile nature of human beings. Burlap is a rough-textured, tough fabric with multiple uses. The loose strands themselves are very strong, but they are even stronger when woven together. The burlap represents the toughness of the African people as individuals, and the potential for extraordinary strength if the people can weave themselves together.

Bringing all of these materials together using the weaving method suggests that despite all the troubles and worries we go through in life we can stand united and fight together for a better and common cause.

—Margaret Allotey-Pappoe

My Africa

This vessel was created using traditional African techniques making use of glass beads in the colours of the current South African flag. Beading is traditionally a female occupation in Africa, especially in black communities. Coming from a western background, it is unusual for a white, Afrikaans-speaking woman to work in a traditional African manner. Yet it is part of my societal and cultural history. Traditionally women would use the different colours in their beaded works to convey messages to their husbands, children, family, and friends. Using the colours of the South African flag, I am writing my own message of hope, courage and faith in our country.

The beaded layer at front of the work appears as if it is opened with a zip. The

A Collaboration among:
Margaret Allotey-Pappoe, Deléne Human, & Jo-Ann VanReeuwyk *continued*

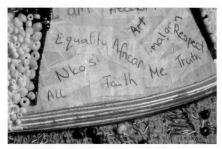

layers underneath represent my western heritage which is overgrown with the "African-ness". The words "I am African" and "I am European" are repeated here and on the inside of the vessel. Yet over the word "European" there are layers of words such as "Freedom", "Equality", "Nkosi" and "Hybrid". It is also here where the value and meaning of the five Rs—Remembrance, Resistance, Reconciliation, Representation, and Re-visioning—becomes evident.

I was born during the apartheid regime, but grew up in a "democracy". Even though the struggles faced in South Africa today were not originally my struggles, they have become my own. As a country we have achieved many things, yet all five Rs are critical issues we are faced with on a daily basis. This work shows that despite the hardship, I am African, and I am proud to be so.

—Deléne Human

Concertina

South Africa seeks equality after many painful years of segregation. Shantytowns continue to exist, home to multitudes. In North America, black people were enslaved for 250 years. "The vending of the black body and the sundering of the black family became an economy unto themselves estimated to have brought in tens of millions of dollars to antebellum America...here we find the roots of American wealth and democracy—in the for-profit destruction of the most important asset available to any people—the family." (*The Atlantic*, June 2014; 63)

"The Homeowners' Loan Corporation in America pioneered the practice of REDLINING [emphasis mine], selectively granting loans and insisting that any property it insured be covered by a restrictive covenant— a clause in the deed forbidding the sale of the property to any other than white." (*The Atlantic*, June 2014; 65) We may be taken aback by the abject poverty in the South African townships but we need look no further than our own backyards and our own heritage to find those same shantytowns and the effects of our own redlining. How do we claim constitutional equality if in fact our homes and our neighborhoods remain segregated and we continue to deny safety, comfort, hope, hospitality, and growth in the very spaces we inhabit.

—Jo-Ann VanReeuwyk

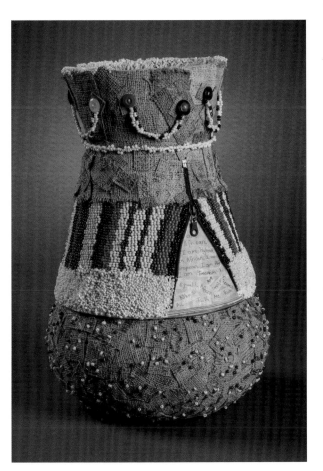
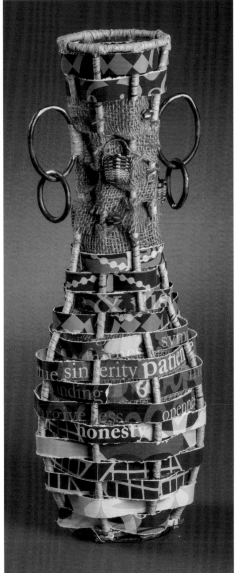

left to right:
INHABIT: shantytown--My Africa,
Awo, Concertina

I wake to August's whimper

it is Monday. the southern hemisphere is closing in on joy
but today the sun has retreated a little
hid his smile to let the broken fangs of winter bite again
in anguish, in failure

below, the drills below are drilling
holes in what should have been a gentler day
there is no peace in the city
no peace to be found in the muchness
 of handling papers or the pillow on the bed

it is Monday. in Khayelitsha, Venancia wakes up at 5am
she sits for an hour or two on the train

 to make beds she never used
 wash clothes she never wore
 clear meals she never ate
 for lords whose teeth she'll never have the bile to break

she dreams of catering and landscaping
 she dreams

but who will have the grace to listen to her dreams
help make a fruitful garden of her desire
who will take her hand?

above, the clouds above are stiff
and just beyond them, in the sham of shamayim
the very 'there' of the sky, there is
a ladder and a gate
and through many tribulations we must enter

it is Monday. spring's approach is already killing so much
of what was once so comforting
so much of the grief which warmed winter

it is Monday: the second day, the second mourning

—Kambani Ramano

Of Nsenga and Venda parentage, Kambani Ramano is learning
what It means to be in the image of the Poet who crafted creation
with words. He lives in South Africa (used with permission)

facing page
Larry Thompson
detail, *An Intentional Intersection* 2013

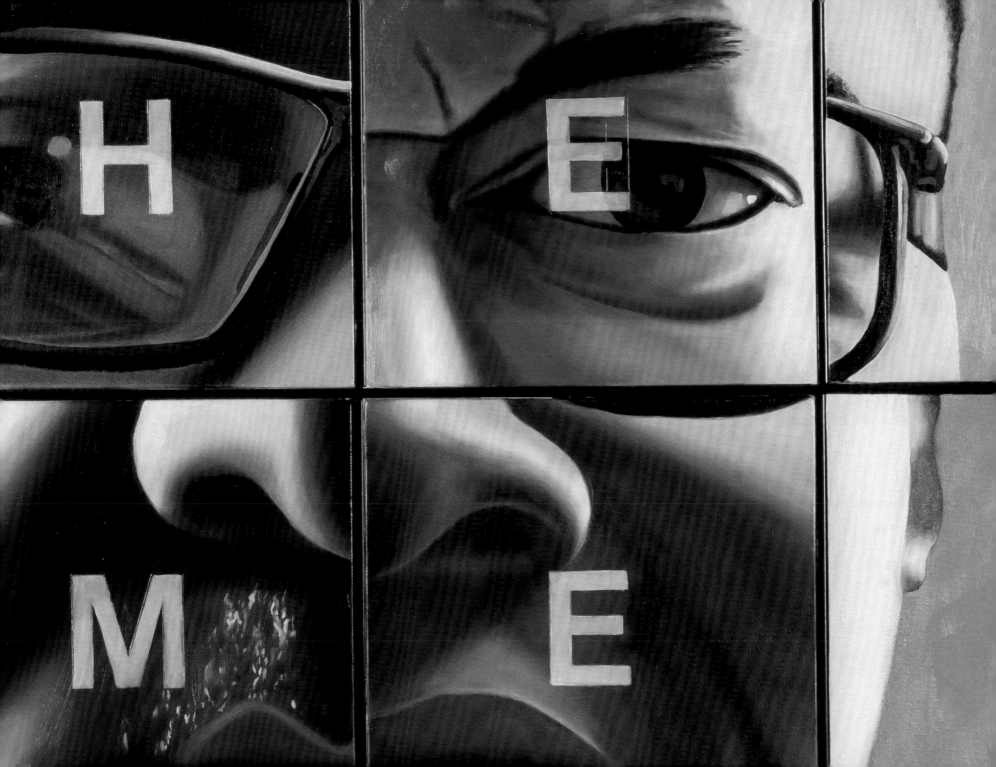

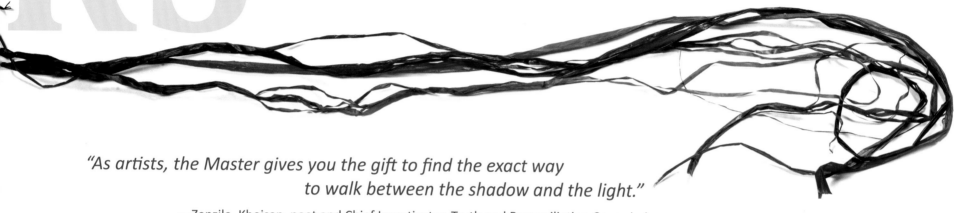

Representation:

in a post-colonial, multicultural society, who may represent whom?

"As artists, the Master gives you the gift to find the exact way to walk between the shadow and the light."
—Zenzile, Khoisan, poet and Chief Investigator, Truth and Reconciliation Commission

"We must learn to live in the tension between what is and what should be."
—Johan Horn, Executive Head, African Leadership Institute for Community Transformation (ALICT)

Studio time at Schoenstatt in Constantia

Biographies ———

Margaret Allotey-Pappoe

Margaret Allotey-Pappoe is a designer, artist and Assistant Professor of graphic design in the Art and Design Department at Mount Vernon Nazarene University in Mount Vernon, Ohio. She was born and raised in Ghana, West Africa and studied communication design at Kwame Nkrumah University of Science and Technology in Kumasi, Ghana where she obtained her B.A. degree. She furthered her studies in the United States where she received an M.A. and M.F.A. degree in visual communication and design from Bradley University. Margaret is the art director and co-founder of eSchoolToday Technologies, an online learning portal for young people, created in 2006 and serves as the faculty advisor for Mount Vernon Nazarene University's AIGA student group. She has been a member of Phi Kappa Phi Honor Society since December 2009. In May of 2007 she served on the Graduate Advisory Committee at Bradley University and received an honorary award from the Slane College of Communications and Fine Arts also at Bradley in recognition of her efforts in the Gallery Program—specifically the 31st Bradley International Print and Drawing Exhibition in May 2007. Her artworks focus on African historical narratives and have been exhibited around the United States; in Illinois, Iowa and Ohio, and in private homes. Margaret's multi-cultural background and experiences drives her to inspire students to work harder to realize their full God-given potential in the field of art and design.

Jonathan Anderson

Jonathan Anderson is an artist, art critic and Associate Professor of art at Biola University in La Mirada, California where he has been since 2006. He holds an M.F.A. from California State University Long Beach, where he received the Distinguished Achievement Award in Drawing and Painting. His work has been exhibited widely, including exhibitions at the U.S. Embassy in Wellington, New Zealand, and Phantom Galleries in Long Beach, California. In addition, Jonathan is a regular speaker and writer about art, focusing especially on bringing contemporary art and theology into more meaningful conversation. His essays have been published in a variety of magazines and journals, including *Religion and the Arts*, CIVA *SEEN* Journal and *The Christian Century*, as well as in books, including *The Renewal of Christian Theology* with Amos Yong (Baylor University Press, 2014) and *Christian Scholarship in the Twenty-first Century* (Eerdmans, 2014). He has given scholarly presentations at Yale University (Society for Christian Scholarship in Music) and the Cathedral of Our Lady of the Angels (Association of Scholars of Christianity in the History of Art), and in 2012 he was a research fellow at the Center for Christian Thought. He is currently co-authoring a book with William Dyrness entitled *Modern Art and the Life of a Culture* (IVP Academic, forthcoming).
www.jonathanandersonstudio.com

Keith A. Barker

Keith A. Barker currently teaches photography and chairs the Art Department at Asbury University in Wilmore, Kentucky. He received his M.F.A. from Savannah College of Art and Design (2000). He photographs people, places and moments that allow for an appreciation for history as well as an acknowledgement of the present. His work features his hometown as well as locations abroad, exploring people and places that point toward stories and universal realities. He has also photographed in locations of spiritual significance around Kentucky such as Cane Ridge and the Abbey of Gethsemani. Keith lives in Wilmore with his wife and three children.
www.kbarkerphoto.com

Joel A. Carpenter Joel A. Carpenter is the director of the Nagel Institute for the Study of World Christianity at Calvin College in Grand Rapids, Michigan. From 1996 to 2006 he was provost of Calvin College. Prior to that he was director of the Religion Program at the Pew Charitable Trusts, a position he took after 12 years of college teaching at Calvin, Trinity International University and Wheaton College. While at Wheaton he was the director of the Institute for the Study of American Evangelicals. He has published a number of works in American religious history, most notably *Revive Us Again: The Reawakening of American Fundamentalism* (Oxford, 1997). His newer publications reflect his growing interest in world Christianity. He is editor or co-editor of three recent books: *Walking Together: Christianity and Public Life in South Africa* (ACU, 2012), *Christianity and Chinese Public Life: Religion, Society and the Rule of Law* (Palgrave-Macmillan, 2014), and *Christian Higher Education: A Global Reconnaissance* (Eerdmans, 2014).

Joseph Cory Joseph Cory is Associate Professor of art at Samford University in Birmingham, Alabama. Prior to joining the faculty at Samford in 2014, he taught art and served as chair of the Art Department at Judson University in Elgin, Illinois. He received his M.F.A. from the University of Chicago, and a B.F.A. from the School of the Art Institute of Chicago. His artwork has been exhibited nationally and throughout the Chicago area. He is the recipient of a number of grants and awards, and has participated in a variety of competitive workshops.

Theresa Couture Theresa Couture is Professor of art at Rivier University, Nashua, New Hampshire, a Catholic institution sponsored by the Sisters of the Presentation of Mary of which she is a member. She has served as co-chair of the Department of Art and Music, is currently Director of the art gallery, and recently was awarded the distinction of artist-in-residence. In addition to a residency at the Kodak Corporation's Center for Creative Imaging she has been an artist and research fellow at the Coolidge Colloquium sponsored by the Association for Religion and Intellectual Life. Her studio emphasis, variably combining digital imaging with drawing, painting, photography, and hand-papermaking, is accompanied by research, writing and lecturing in art. Theresa holds a B.A. and M.A. in English Literature from Rivier College, an M.F.A. in design from the Rhode Island School of Design, and a D.Min. in theology and the arts from the Graduate Theological Foundation. She has also studied at the Graduate Theological Union and the Andover Newton Theological School, as well as at various art venues, and has received grants for studio and research projects in the United States and Europe. She has exhibited nationally, including at The Museum of Biblical Art in New York City and the Currier Museum of Art in New Hampshire. Her work is in public and private collections, and has appeared in such publications as *Art New England, Christianity and the Arts, The Next Generation*, and *Let This Mind Be in You*, a CIVA limited edition portfolio of original prints.

Katie Creyts

Katie Creyts is an artist and art professor living in Spokane, Washington. Her work involves strangely resonant yet idiosyncratic objects that challenge the difference between "reality" and "fantasy" by entangling both concepts. She has found that the medium of glass, the qualities inherent in glass and mixed media provide a unique playground for exploring this subject. Creyts has an M.F.A. from Illinois State University, a B.F.A. from Tyler School of Art, and has received scholarships for study at The Skowhegan School of Painting and Sculpture, Pilchuck Glass School, and The Studio at the Corning Museum.

Deléne Human

Deléne Human was born in 1988 and raised in Pretoria. She received her B.A. in fine arts *cum laude* in 2010 and a post-graduate certificate in education in 2011, both from the University of Pretoria. At this writing, she is in the process of completing her M.A. in fine arts, also at the University of Pretoria, with her research paper titled: *The fusion of horisons: Interpreting the archetype of the resurrection myth in contemporary visual art*. In 2012 Deléne worked as a junior lecturer at the University of Pretoria in the Visual Arts Department and since 2014 she has been the subject head in the Arts Education Department while simultaneously serving as a part-time lecturer at the Tshwane University of Pretoria in the Sculpture Department. From 2012 to 2014 she was also the gallery manager at Gallery 2 in Johannesburg. Deléne's final year exhibition titled *Consecration* in 2010 marked the beginning of her professional career as an artist. Since then she has participated in and curated various group exhibitions. Her art generally deals with the theme of resurrection— that is, life after death. Not only through her subject matter, but also through the use of medium, technique and site, she attempts to portray how it is possible to bring something that was thought to be dead back to life.

Jackie Karuti

Jackie Karuti was born in Nairobi, Kenya. She studied graphic and multimedia design but largely considers herself a self-taught artist. Jackie works primarily in the medium of painting but with her gradual embrace of new media, she has incorporated a conceptual and experimental approach to her work. Her work's main focus explores themes of gender, identity and urban culture using installation art as well as video and still performances. Jackie has exhibited and participated in workshops in Kenya, Nigeria, Senegal and South Africa. Notable works include her solo show at the Goethe Institut, Nairobi (2014) and a video performance shot in Johannesburg (2014). She is a recipient of the Moving Africa grant by the Goethe Institut (2014) and was an artist-in-residence at The Bag Factory in Johannesburg in 2014 and the Centre for Contemporary Art in Lagos in 2012. Jackie has collaborated in various photography and film projects and is an avid writer as well. She lives and works in Nairobi.
www.thethirdroomstudios.blogspot.com

Keatlaretse Kate Kwati

Keatlaretse Kate Kwati is a practicing visual artist and teacher of art and design in Botswana. She earned her B.A. in fine art from Michaelis School of Fine Art at the University of Cape Town, South Africa. She teaches art at a school for disabled and visually impaired young people encouraging them to express themselves as well as to use art as a therapeutic tool to deal with their impairments. She also works with groups of women to teach them skills like embroidery, beadwork, painting, weaving, jewelry design and printmaking. One of the highlights of her career was working with a group of mentally challenged women through the Sedibelo Heritage Art Therapy Project which she co-founded with the local authorities in Mochudi village to help homeless and destitute women. The highlight of this project was two very successful exhibitions in Botswana and South Africa where proceeds from the sale of the works went to the artists. These are the kinds of projects that drive Kate as an artist. Some day she would like to study art therapy so that she might be more fully equipped to assist in these challenging situations. Kate's artwork is included in private, corporate, and governmental institutions in Botswana, South Africa, and Namibia, in the Michael Stevenson Gallery in Cape Town, the Botswana National Gallery and in London. She has received many awards and recognitions for both her art and teaching. Her work has been featured in exhibitions in Namibia, South Africa, Swaziland, London and China, as well as in her home country of Botswana.

Xolile Mazibuko

Xolile Mazibuko was born and raised in Kwa-Zulu Natal in South Africa. She attended Mafu High School where she started to work as an artist. In 2002 she won the competition of Ukhahlamba Local Municipality. Currently Xolile works as a visual artist at the BAT Centre in Durban, South Africa, an arts and culture community centre. The BAT Centre's mission is to celebrate the arts and culture of Durban, Kwa-Zulu Natal and South Africa by promoting local talent and skills. Xolile is a painter, working in oil and acrylic on canvas, wood and ceramic, interested in religion and the current generation. She continues to develop her skills by participating in workshops. Her work has been exhibited in many exhibitions in a variety of galleries, is sought after through commissions and sales in the studio.

Valentine Mettle

Valentine Mettle is an artist and graphic designer born in 1961 in Lagos, Nigeria where he developed a passion for nature and the sea. He schooled at Zion Secondary School in Anloga, Ghana where he obtained the West African School Certificate. He studied fine art and textile design graduating with a Higher National Diploma (HND), an indication of his versatility, from Yaba College of Technology in Nigeria in1988. He also studied computer graphics at the University of South Africa (UNISA) earning a certificate in 2008. He has had many solo and group exhibitions in Ghana, Nigeria and South Africa. His works can be seen in public places, homes and government establishments. Valentine moved from Nigeria to South Africa due to social and political unrest. In South Africa he worked with SA Greetings, a subsidiary of USA Greetings, and made unique handmade cards for the company called HOMEGROWN. His work combines a love for color and movement, pattern and texture to create dramatic scenes. He also enjoys working in pastel and acrylic wash on location or with the subject before him. Inspiration comes from his moods, emotions, dreams and aspirations as well as from those of other beings.

Phumlani Mtabe

Phumlani Mtabe is a professional graphic designer who lives in Kayamandi, South Africa. He did his B.A. in applied design majoring in graphic design at Stellenbosch Academy of Design and Photography. In 2010 he was selected to take part in the master class of a professional South African political cartoonist that included the famous artist, Zapirow. In 2012 Phumlani worked as a design intern at Flame design. In 2013-2014 he worked at Live SA Magazine as a part-time designer. He currently works as freelance designer and photographer and likes to do fine art painting in his extra time.

Petros Mwenga

Petros Mwenga was born in 1985 in Harare, Zimbabwe. His artistic abilities were recognized from an early age when he won two merger prizes in 2002 and 2004. He pursued art at the Peter Birch School of Art in Harare where he received a certificate. He also attended the National Art Gallery of Visual Arts where he received his certificate of completion. In 2008 Petros participated in a National COTCO competition and received a merit award in the painting category. From 2006 to 2008 his art was exhibited at the Delta Gallery. He has also been involved in the Young Artist exhibitions in 2006, 2007 and 2008. In 2009 Petros was involved in the Post-Election Exhibition as well as the Enriching Women and the Land Exhibitions. He has participated in more than 20 national and international exhibitions where his work has also been featured in a variety of publications. His work has been exhibited at the Venda Gallery and Picture Flame Gallery in Zimbabwe, and the Gerald A. Lee Gallery in Johannesburg. Petros uses mixed mediums and specializes in portraits. He is currently based in Johannesburg, South Africa.
www.petrosmwenga.wordpress.com

Charles Nkomo

Charles Nkomo was born and raised in Bulawayo, Zimbabwe. Realizing that art was the one thing for which he had a passion, he applied to and was accepted to the Mzilikazi Art School where he specialized in fine art. He then became a resident artist at the National Gallery in Bulawayo from where he successfully pursued his career, participating in numerous exhibitions and winning awards including an award for excellence from the Watercolour Society of South Africa's 10th Black Like Us Exhibition in 2013. Charles has been commissioned by a number of organizations over the years to paint a variety of murals—at the Amakhosi Theatre in Bulawayo, Kana Mission and St. Francis Church, Yeoville parish in Johannesburg. He paints temporary murals each year for the Bulawayo Trade Fair. He considers his work "abstract expressionist". Asked about his choice of subject matter he explains, "It is influenced largely by my socio-economic and political environment, for I do not live in isolation. Therefore activities around me and current events tend to play a great role in what I paint and sometimes my projections on future events find themselves on my canvasses like prophesies." Beyond Zimbabwe his work has been shown at the Dumela Art Gallery, Chicago and Amazwi Art Gallery in Michigan in the United States, Guruve Ltd. in the United Kingdom, the Dutch Boarder Bentheim J.B. Gallery in Germany, and Alice Art Gallery, Gallery on the 6th, and the ABSA exhibition in South Africa.
www.aliceart.co.za
www.amazwi.com
www.guruve.com

Magdel van Rooyen

Magdel van Rooyen was born in Pretoria, South Africa in 1983. After relocating several times she returned to Pretoria to complete her undergraduate qualifications and also obtained her master's degree in fine arts from the University of Pretoria. She specialized in installation art dealing with the theme of place, space and liminality which results in the psycho-geographic state of being in between. Even though she focused on installation art, Magdel sees herself as a process oriented artist allowing the theme of her work to depict her medium. Her work has been showcased in the PPC Young Sculptors Awards in 2004 and the ABSA L'Atelier in 2006. In 2012 Magdel was selected for the Art-St-Urban working residency in Switzerland that provided her with the opportunity to be part of Art Basel 2013. She lectured in painting, sculpture and drawing at the University of Pretoria's Fine Arts Department for seven years upon which she assisted as principle at a design college. She currently resides in Pretoria producing and teaching art.

Allen Sibanda

Allen Sibanda is a mixed media artist who lives in Bulawayo, Zimbabwe. He studied art at St. Pius College from 1996-1997. From 1999-2007 Allen maintained a studio at the National Gallery in Bulawayo. His work has been featured in many national and international exhibitions including Telling the Truth(Bulawayo Club) and Poetic Brush (National Gallery in Bulawayo) in 2010, Gwanza Photography (National Gallery in Harare) in 2009, the Samporia International Art Exhibition (Sweden, Berlin, Amsterdam) in 2000, and Visual Artists Association of Bulawayo (National Gallery in Bulawayo) from 1996-2001, and in a solo exhibition titled the Eyes of Faith (National Gallery in Bulawayo) in 2000. His work has received recognition from early in his career with awards like 2nd prize for Sculpture in the Scandia Wire Art Exhibit in 1997, and an Award of Merit in Photography (Zimbabwe Heritage Biennale) and Young Artist of Promise(National Gallery in Bulawayo) in 2000. Allen's work has received extensive international exposure as a result of selection for 100curators, 100days (Saatchiart.com), Naima Keith's collection, in 2012 and the World Wide Wall (Saatchiart.com), Wangechi Mutu's collection, in 2013. He works in a variety of different mediums allowing the subject at hand to influence his choice of medium.
www.saatchiart.com/allensibanda

Rachel Hostetter Smith

Rachel Hostetter Smith is Gilkison Professor of Art History at Taylor University where she also serves on the honors faculty. Previously she was a member of the graduate faculty of the School of Comparative Arts at Ohio University. She received her Ph.D. in art history from Indiana University after she worked in book publishing and art direction for many years. Rachel has been a visiting scholar, seminar leader, and visiting professor in Rome, Paris and New York, and has taught courses in Italy, British Columbia, Canada, South Africa, and China. Awards for her scholarship include the Albert W. Fields Award for Best Article of the Year and the Forman Distinguished Faculty Scholar Award at Taylor University. Recent publications include serving as co-editor of special issues of the journals *Religion and the Arts* on Latin American Art (2014) and CIVA *SEEN* on African interactions (2014), and a book chapter on the "imagery of abundance" at Orvieto Cathedral in *ReVisioning: Critical Methods of Seeing Christianity in the History of Art* (Wipf and Stock, 2014). She serves on the Board of Directors for the Association of Scholars of Christianity in the History of Art (ASCHA) and was Curator and Project Director of the international traveling exhibition *Charis: Boundary Crossings—Neighbors Strangers Family Friends*.

Katherine Sullivan

Katherine Sullivan received her B.F.A. from the University of Michigan in 1997. In 2001 she received her M.F.A. in painting and drawing from Boston University, where she studied with John Walker and was the recipient of the Richard Ryan Sr. Memorial Award in 2000 and the Graduate Teaching Award in 2000-2001. Additional programs of study include the Chautauqua Institute, the New York Studio School and the Pennsylvania Academy of Fine Arts. She has held fellowships at Cooper Union, the Virginia Center for Creative Arts, and the Wurlitzer Foundation in Taos. Recent solo exhibitions include Past Perfect at Ithaca College's Handwerker Gallery in Ithaca, New York, Body Electric Remix at the University of Indianapolis, and Outlier at Jamia Millia Islamia's M.F. Hussain Gallery in Delhi. Katherine's studio work has taken her to Newfoundland, South Africa, and most recently, India, where she was a 2013-14 Fulbright-Nehru Scholar, working with graduate students at Jamia Millia Islamia and researching Indian painting traditions and the use of color in Indian art. She often works collaboratively with poets and choreographers. Her work has been incorporated in dance performances throughout the Midwest and Japan. In 2009 one of her paintings was used by American Ballet Theater to premiere their season at the Metropolitan Opera House at Lincoln Center. She's presented her work at School of Visual Arts, Mid-America College Art Association and College Art Association conferences. She's currently a member of the College Art Association's Professional Interests and Practices Committee.
www.katherineasullivan.com

Larry Thompson

Larry Thompson serves as Professor and Associate Dean of Art and Design at Samford University in Birmingham, Alabama. Prior to his tenure at Samford Thompson taught in Texas, Louisiana, and Arkansas. A native of El Paso, Texas, Larry received his B.F.A. in art and design from the University of Texas at San Antonio, and his M.F.A. in painting from the University of North Texas. He is an active member of the College Art Association routinely serving as Career Mentor for junior faculty at the annual conference. Larry's work has been exhibited nationally in numerous exhibitions, recently in Alabama, Tennessee, Louisiana, California, Maryland, New York and South Carolina. He is represented in the Birmingham area by Space One Eleven, and in that space during the fall of 2015 will present a solo exhibition and installation, The Infanttree Project, partially funded through a grant from the Andy Warhol Foundation.
www.artbylarrythompson.com

Jo-Ann VanReeuwyk

Jo-Ann VanReeuwyk is a professor at Calvin College in Grand Rapids, Michigan where she is Director of the art education program and Chair of the Department of Art and Art History. Her fiber work is shown nationally, has been in several traveling exhibitions and is included in *Lark Books 500 Baskets*. She worked with Rachel Smith on *Charis: Boundary Crossings—Neighbors Strangers Family Friends*, an international traveling exhibition of Asian and North American artists sponsored by the Nagel Institute. She is currently engaged in a research project called "Sacred Space Pedagogy" that will culminate in publication in the spring of 2015.
www.jo-annvanreeuwyk.com

Kimberly Vrudny

Kimberly Vrudny is Associate Professor of systematic theology at the University of St. Thomas in St. Paul, Minnesota. She is the author or editor of several works in theology and the arts, and is the senior editor of the academic journal, *ARTS: The Arts in Religious and Theological Studies*. Her photography exhibit *30 Years/30 Lives: Documenting a Pandemic* is currently traveling nationally and internationally (www.30years30lives.org). Her forthcoming book is titled, *Beauty's Vineyard: A Theological Aesthetic of Anguish and Anticipation*, in which she writes a theology informed in large measure by encountering a sorrowful Beauty who sings laments and issues prophetic oracles in the refugee camps of Israel/Palestine, the townships of South Africa, rehabilitation centers for those violated by human trafficking in Thailand, Zapatista communities in Mexico, and in pockets of the United States where poverty, food deserts, and structural violence coalesce to produce inhumane living conditions. In her photography and academic writing, she is sketching a vision of loving kindness and of *shalom*—a vision rooted in Jesus' imagination of a restored community—in the hope that, by an ability to imagine what it looks like, it will become easier to bring it into being. This is a lesson she learned in South Africa, which has avoided war, she has been told time and again, because South Africans, deeply formed by the philosophy of *ubuntu*, have always imagined a different way of being human in community.

Michelle Westmark-Wingard

Michelle Westmark-Wingard is Associate Professor of Art and Gallery Director of Bethel University's two exhibition spaces. Previously, she was Assistant to the Gallery Director in Pratt Institute's Department of Exhibitions and had the opportunity to work with Creative Time and A.I.R. Gallery in New York City during graduate school. Her photographic and curatorial endeavors often explore themes of identity, perception and interconnection in an increasingly globalized digital world. She has curated several exhibitions and has also exhibited her own photographic work locally and nationally. She received her M.F.A .in photography from Pratt Institute in Brooklyn, New York in 2006. She lives and works in Minneapolis, Minnesota.

Joel Zwart

Joel Zwart is Director of Exhibitions at Calvin College in Grand Rapids, Michigan where he oversees the Center Art Gallery on campus and the (106) Gallery downtown. He also directs other college-related exhibitions and manages the college's permanent collection of over 1600 pieces of artwork. Zwart graduated from Calvin College in 1997 with a B.A. in history and emphasis in art and French, and earned an M.A. in historical administration from Eastern Illinois University in 2000. Recent exhibitions curated and juried include *Striking Impressions: Japanese Woodblock Prints from the Permanent Collection, 90 Years of Collecting: Looking Back & Looking Forward, The Father and His Two Sons—Images of the Prodigal Son from the Larry and Mary Gerbens Collection, Curse or Calling? At Work in God's World,* and *Transformation Tools: Alutiiq Masks of Kodiak Island.* Zwart also served as onsite curator for the international traveling exhibition *Petra: Lost City of Stone* at Calvin College in 2005. He currently serves as a member of the Christians in the Visual Arts (CIVA) Exhibition Committee and the Inner City Christian Federation (ICCF) Art Exhibition Steering Committee and is treasurer of the Grand Rapids Gallery Association (GRGA). www.calvin.edu/centerartgallery

Moment by moment

For the fallen heroes

If a thousand graves could speak
They would speak of freedom
If a thousand graves could sing
They would sing of freedom
If a thousand graves could dream
They would dream of freedom
If a thousand graves could resurrect
They would live to face that day again

June 16, when God forgot his black children
June 16, when innocent blood flowed like a river
And God closed his eyes
June 16, when screams rang out from the wombs of heroic mothers
And God closed his ears

June 16, when the midday sun refused to shine

But the spirit lives on, June 16
Speaks, lives, dreams
From a thousand graves
Moment by moment
Moment by moment

 —Zenzile Khoisan, June 1985
 (used with permission)

facing page
Valentine Mettle
detail, *From Struggle to Victory: Release* 2013

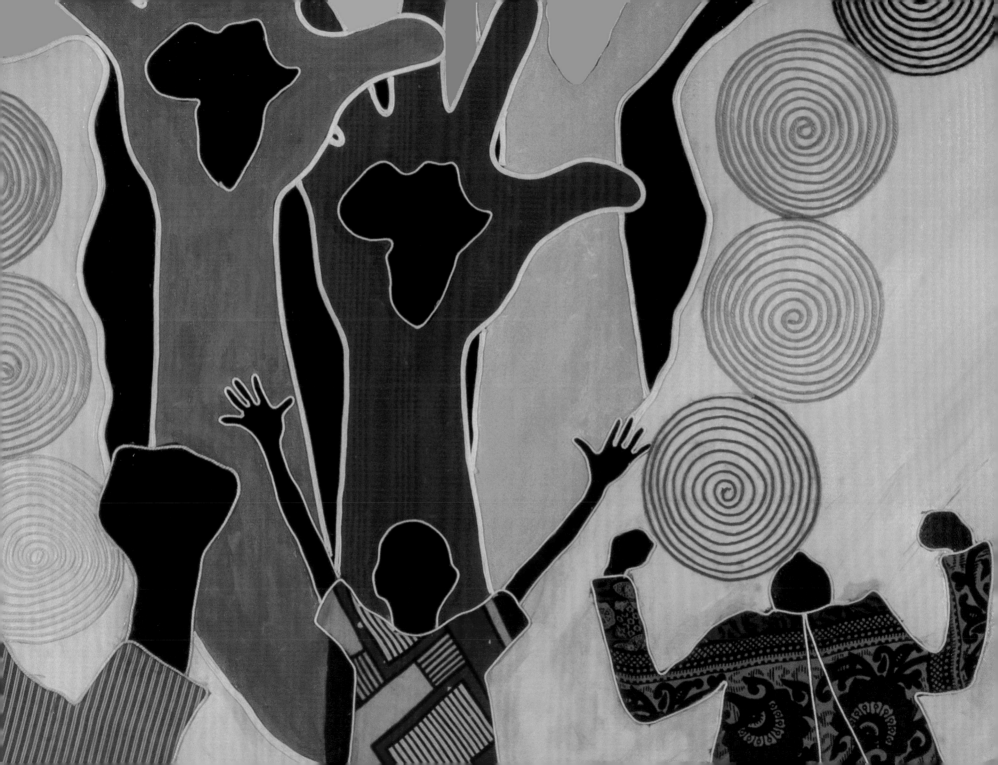

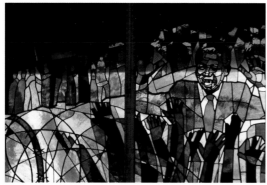

R5

Re-Visioning:

how does hope factor into artistic imagination?

*"The artist imagines the spring
long before the buds are on the tree."*

—Zenzile Khoisan, poet and Chief Investigator
Truth and Reconciliation Commission, referring to a poem by
Chilean poet Pablo Neruda "that kept him company at the TRC"

*"Sometimes the dreams that come true
are the dreams you never even knew you had..."*

—Alice Sebold, *The Lovely Bones* (2002)

QUO VADIS?

*above, center: stained glass at Regina Mundi
Roman Catholic Church in Soweto
right: Danie de Jager (1936-2003), Quo Vadis?*

Complete Artworks

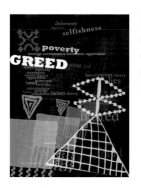

Margaret Allotey-Pappoe
Hekonn ("Greed" in the Ga dialect
of Ghana) 2013
digital print on paper
30" x 40"

Jonathan Anderson
Cape Town, ZA / Long Beach, CA 2013
oil on unstretched canvas
48" x 72" x 72"

Jonathan Anderson
Robben Island, B-Section 2013
oil on canvas
48" x 36"

Jonathan Anderson
Property Lines 2013
acrylic on wood and A4 sheets of paper
each house: 11 ¹¹⁄₁₆" x 8 ¼" x 10"
dimensions of paper grid variable
(grid shown is 66 ¼" x 82")

Jonathan Anderson
Apocalypse 2013
archival inkjet prints on paper
60" x 20"

Jonathan Anderson
Memorial 2013
rock, masonry, and asphalt on lace tablecloth
60" diameter x 7"

Keith Barker
The Queens of Soweto 2013
toned, silver gelatin print
19" x 12"

Keith Barker
Somewhere Else 2013
80-page hardcover art book
10" x 8"

Keith Barker
Tension: On the Way to Robben Island
2013
dye-sublimated print on aluminum
30" x 20"

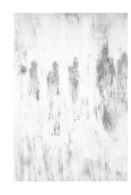

Joseph Cory
All that Lies Behind Us 2013
oil and cold wax medium on panel
17 ½" x 23 ½"

Keith Barker
Commemoration 2013
digital real-time video with audio
running time 2:08 minutes

Joseph Cory
Trespassers on Our Own Land 2013
oil and cold wax medium on canvas
19 ¼" X 25"

Joseph Cory
The Unnamed Few (After Judith Mason)
2013
oil and cold wax medium on panel
8" x 12"

Theresa Couture
Duet 2013
archival pigment print from combined media
20" x 15"

Theresa Couture
Holy the Day (diptych) 2013
 Morning Curtain: The Hour of Lauds
 Evening Cavern: The Hour of Vespers
archival pigment prints from combined
media on rag paper
each 13" x 17"

Joseph Cory
Winter Flowers ZA (series of 4)
2013
 Sometimes You...
 The Struggle Continues
 We have Made...
 Untitled
oil pastel, india ink and acrylic
on paper
each 11" x 15"

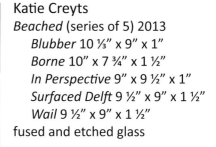

Katie Creyts
Beached (series of 5) 2013
 Blubber 10 ⅓" x 9" x 1"
 Borne 10" x 7 ¾" x 1 ½"
 In Perspective 9" x 9 ½" x 1"
 Surfaced Delft 9 ½" x 9" x 1 ½"
 Wail 9 ½" x 9" x 1 ½"
fused and etched glass

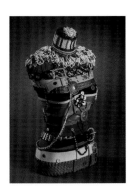

Deléne Human
Hunger Belts—The Rainbow's Hope
2013
mixed media construction
16 ⅛" x 27 ¼" x 8"

Keatlaretse Kate Kwati
in collaboration with Rachel Hostetter Smith
Ties that Bind: The Fabric of Our Being
2013-2014
aluminum print collage of 9 stills
from artist performance
2 8"x8" prints and 7 10" x 8" prints

Deléne Human
Double Negative (series of 6) 2013
　　God's Washing Line
　　Krag
　　God's Washing Line
　　Krag
　　My krag kom von bo
　　My daaglikse Brood
2 drawings with charcoal and ink on
paper and 4 photographs
each 16 ½" x 11 ⅘"

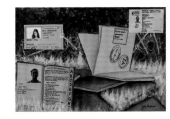

Xolile Mazibuko
A Woman's Day in South Africa 2014
acrylic on canvas
30" x 20"

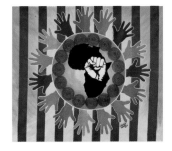

Valentine Mettle
From Struggle to Victory: Resistance 2013
mixed media: acrylic, thread,
and fabric on canvas
59" x 49"

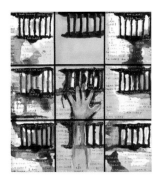

Jackie Karuti
Stefaans' Letters 2013
acrylic and pastel on canvas
32" x 36"

Valentine Mettle
From Struggle to Victory: Petition 2013
mixed media: acrylic, thread,
and fabric on canvas
59" x 49"

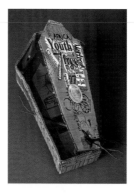

Phumlani Mtabe
The Hole Truth 2013
cardboard and paper construction
with markings and barbed wire
8" x 14 ¼" x 5"

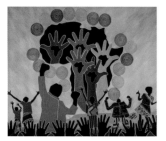

Valentine Mettle
From Struggle to Victory: Release 2013
mixed media: acrylic, thread,
and fabric on canvas
59" x 49"

Petros Mwenga
Man in the News 2014
mixed media and collage on canvas
23 ⅔" x 35 ⅘"

Phumlani Mtabe
Is Design a Solution? 2014
digital print on aluminum
24" x 12"

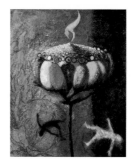

Petros Mwenga
Protea 2013
oil and mixed media on canvas
29 ⁹⁄₁₀" x 35 ⅖"

Charles Nkomo
Moment by Moment 2013
acrylic on canvas
39 ⅓" x 29 ½"

Magdel van Rooyen
Visual Diary: R5 Journal 2013
mixed media: paper with markings,
thread, ribbon, and cloth tape
A5 booklet in 6 ½" x 8" leather case closed

Charles Nkomo
Reflections 2013
acrylic on canvas
39 ⅓" x 29 ½"

Allen Sibanda
I know a place (still mending) 2013
x-ray sheet and thread on canvas
27 ¾" x 28 ¾" frameds

Magdel van Rooyen
Constructing Hope 2013
oil on metal plate
54" x 31 ½" x 1 ⅔"

Allen Sibanda
Scars will always remain 2013
x-ray sheet and thread on canvas
27 ¾" x 28 ¾" framed

Katherine Sullivan
Chronicle I; My Traitor's Heart 2013
oil on canvas
36" x 48"

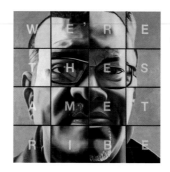

Larry Thompson
An Intentional Intersection 2013
oil on canvas
49" x 49"

Katherine Sullivan
*Purple Shall Govern II,
Interrupted Atman* 2013
oil on canvas
48" x 36"

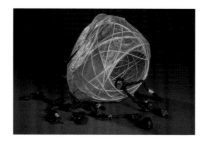

Jo-Ann VanReeuwyk
Tyre 2013
reed, hog gut, rubber, stones
12" x 9" x 15"

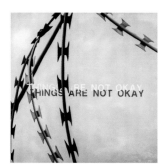

Larry Thompson
Barriers Still 2013
oil on wood
48" x 48"

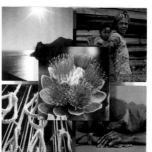

Kimberly Vrudny
Beauty's Vineyard (*Theology, Anthropology,
Soteriology, Pneumatology, Eschatology*) 2013
construction of photographs printed on metal
16 ½" x 16 ½"

Collaborative Work:
From My Side of the World 2014

Michelle Westmark-Wingard
& Magdel S. van Rooyen
video projection
running time: 19:30 minutes

Between the Shadow and the Light 2014
video produced by **Marie Midcalf** and
Film School Africa
running time: approx. 8 minutes

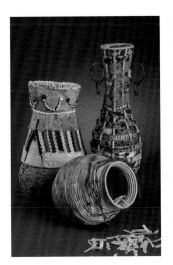

Collaborative Work:
INHABIT: shantytown 2013

Margaret Allotey-Pappoe
Awo mixed media: metal, raffia, burlap,
beads, bamboo and paper
8 ½" x 20 ½" 8 ½"

Deléne Human
My Africa mixed media: metal, hessian,
glass beads, buttons, copper wire, and paper
12" x 17 ½" x 12"

Jo-Ann VanReeuwyk
Concertina mixed media: raffia, barbed
wire, and handmade paper
12" x 13 ½" x 12"

Supplementary Works produced in studio in Constantia, South Africa:

Joseph Cory
Winter Flowers 2013
collage on paper
23 ¼" x 15 ½"

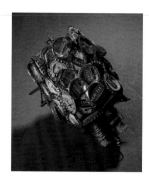

Magdel van Rooyen
Rusted Protea June 2013
found object construction: wood,
bottle caps, nails, and wire
4" diameter x 7" long

Katie Creyts
Compass June 2013
found object construction: plastic,
paper, with pastel and graphite
7" diameter x 4 ½"

Collaborative Work:
Protea Flowers June 2013
Keith Barker, Joseph Cory,
& Deléne Human
found object construction: plastic bottles,
tubing, bags, paper and raffia
4 pieces, each 4" diameter x 12" to 16" long

Larry Thompson
Link June 2013
found object construction: wood, seeds,
glue, rusted metal, and raffia
9" x 9" x 1 ½"

Put it on the Table June 2013
Group Collaboration produced in studio in
Constantia, South Africa
59 ½" wide, variable length

א

a thing as simple as the moon
 a ball
of grey dust

at dusk in the sky
reflecting light

how beautiful

ב

this is the moon:

 a sign
 for months and the new day

 a beacon
 for those adrift on the ocean
 of time, routine
 the repeated rhythm of sleep and wake
 sleep and wake to the roar of swarms of paper
 copiers and printers which churn deep into dark hours

 a lamp
 she is the lessor light
 to govern night
 to rule over the waters and their swimming multitudes
 reflect her bridegroom lord, the sun

 until he rises from the east
 with the blast of the last shofar
 until he sits upon Mount Zion
 and darkness is no more

 on that great and endless day
 they will cling to each other, the two
 and their glory will be one

—Kambani Ramano
Of Nsenga and Venda parentage, Kambani Ramano is learning
what It means to be in the image of the Poet who crafted creation
with words. He lives in South Africa (used with permission)

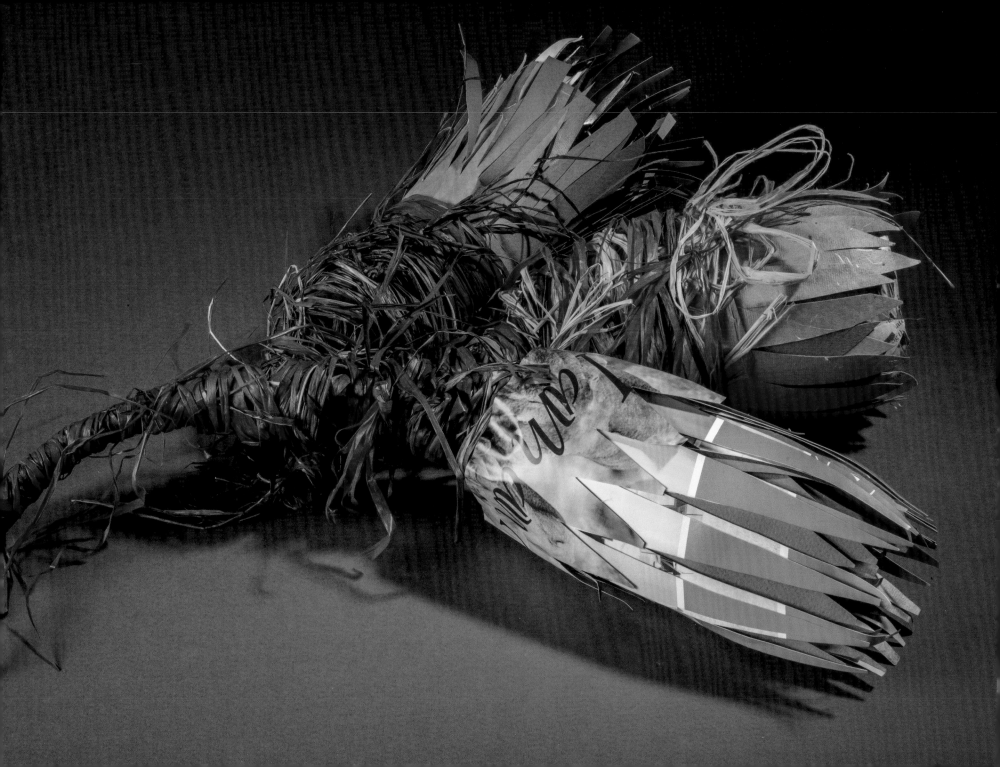

Acknowledgements

Curating an art exhibition is a lot like being the conductor of a symphony concert, marshalling the gifts of countless people on stage and behind the scenes to produce a memorable event. As with a musical performance, the reception of the original artwork—the work of hands of the artists featured in the exhibit in this case—partakes to a very great extent on the interpretation and presentation of a host of committed creatives lending their time and talent to showcase that work in the most effective manner. That is certainly the case with this exhibition, which from its inception required the involvement of many others.

I have been privileged to partner once again with Jo-Ann VanReeuwyk and Joel Zwart of Calvin College who lent their expertise and effort in whatever way the project required. Each has given generously of their time, energy, and talents from the initial selection of the works to a travel-ready exhibit, pressing against a demanding schedule to launch this exhibit in time for its inaugural installation in New Orleans. Joel marshalled the exhibition prep team that included Reed Bowden, who helped with the carpentry of museum-standard shipping crates, and Betty Sanderson of the Art Department who gave meticulous care to everything from matting and framing the works to preparing the labels and documentation needed for successful tracking and travel. Their attention to detail and standards of excellence is unmatched.

The volume you hold in your hands now is also the result of the ingenuity and skills of many. Krista Krygsman, graphic designer, partnered with me to develop the design and layout producing a magnificent result. I am grateful for her creative gifts and technical skills, and her patience in working side-by-side with me for many long and late hours. The art photography done by John Corriveau speaks for itself! While R5 artists Keith Barker and Larry Thompson gave me full access to their seminar photos to enrich this catalog, saying, "Whatever you need, Rachel. Just say the word." Gary Lepsch at Calvin Printing Services shepherded the production process with

left: Collaborative Work:
Protea Flowers June 2013

Rich Baarman of Holland Litho, our printer, and provided design and printing advice that helped me to think more creatively about how to make my loosely formed ideas manifest in print. Beyond the visual artists, South African poets Zenzile Khoisan and Kambani Ramano generously allowed us to include their poetry in this publication, and R5 artist and theologian Kimberly Vrudny provided a thoughtful and thought-provoking essay to enlarge our engagement with the significant issues this exhibit will certainly raise in the minds of many who view it. And I am especially grateful to the many people we met on our journey together who inspired us and provided us with words that crystalized so much of our understanding of South Africa and what we could learn from our time together there.

This exhibit has its origin in "R5," an international faculty development seminar in the visual arts held in South Africa. It was cosponsored by the Council for Christian Colleges and Universities and the Lilly Fellows Network of Church-Related Colleges and Universities, so the American half of the seminar team was made up of visual arts faculty from member colleges and universities of these two outstanding consortia. The operating partner for this project is the Nagel Institute for the Study of World Christianity, a research and projects agency of Calvin College. Joel Carpenter of Calvin College and I were the seminar leaders. We are grateful for the expert project administration of Donna Romanowski at the Nagel Institute and the kind assistance of Phoebe Milliken and Bob and Alice Evans of the Plowshares Institute in Simsbury Connecticut, all veterans of many international projects. Plowshares staff arranged travel, as well as

R5 participants Jonathan Anderson, United States, and Allen Sibanda, Zimbabwe during the seminar

Johan Horn of ALICT who inspired us to "live in the tension between what is and what should be."

many of the contacts and meetings for the project and provided some expert training in transformative cross-cultural learning. And Charles Nkomo provided essential assistance in identifying African artists to participate and teambuilding while we were together. We owe a debt of gratitude to all of these agencies and agents for their encouragement, promotion and expert assistance.

In South Africa we were greeted warmly at every turn by our contacts, docents and hosts, who graciously gave of their time, their experience and their wisdom. We are grateful to artists and community arts leaders Linda Leibowitz and Taryn of William Kentridge's studios, David Krut and Stephen Hobbs of David Krut Projects, artist Diane Victor, Musha Neluheni of the Johannesburg Art Gallery, Kim Berman of Artist Proof Studios, Celia DeVilliers and Gwen Miller of the *Journey to Freedom Narratives* Project at the University of South Africa and Bongani Mkhonza at the UNISA Art Gallery who mounted a special exhibit just for our group, Stacey Vorster, Curator of the Constitutional Courts in Johannesburg, Professor Tinyiko Maluleke and so many of the arts faculty and staff of the University of Johannesburg including Annali Dempsy, Ashraf Jahaardien, Moira de Swardt and Adan Wyatt who put together a remarkable line-up of events for our group to experience, Marie Midcalf--who produced a video on our journey along with Katie Taylor of Art School Africa and their talented students who taught us much about the transformative power of art—and Zenzile Khoisan, journalist, poet and chief of investigation for the Truth and Reconciliation Commission. At each of these visits, artists shared freely with us their hopes and concerns and their artistic passion. We are in their debt for their openness and generosity.

But our visit was not just about art, and we were also powerfully served by our guides and teachers for history, religion and politics. We are grateful, first off, to our two daily site visit coordinators, Molefi Mataboge in the Gauteng region and Keith Sparks, who guided us through the Western Cape. These gentlemen shared freely from their lives to help us appreciate South Africans' journey through the past thirty years. We also acknowledge the insights and hospitality of Professor Piet Miering of the University Pretoria, Rev. Paul Verryn and the staff of the Central Methodist Mission, Noor Ebrahim and Tina Smith of the District 6 Museum, the late Professor H. Russel Botman, Rector and Vice-Chancellor of Stellenbosch University to whom this catalog is dedicated, Johan Horn of the African Leadership Institute for Community Transformation, Rev. Spiwo Xapile and the staff of the J.L. Zwane Memorial Church in Gugulethu, Lynette Maart of the Memory and Witness Centre and Mary at St. George's Cathedral in Cape Town, and Archbishop Desmond Tutu.

We had three "headquarters" while in South Africa, where every day we were greeted, fed and encouraged in our work by some unforgettable hosts: Sister Jackie of the Koinonia House in Johannesburg, Gerhard Botes of the Signal Hill Lodge in Cape Town, and Sister Heidi of the Schoenstatt Retreat Centre in Constantia. They provided comfort food and a gracious home base for fellowship and reflection after some very

Noor Ebrahim speaks to the group about his family's forced relocation at the District 6 Museum

challenging days. We are also grateful to Lyndy Haslam and her many friends who welcomed the American team in Lyndy's home for a final evening of South African hospitality before we departed for the U.S. the following day.

It is impossible to express how each of these persons (with the help of many others who made our visits "happen" who must remain unnamed here) informed our understanding of the complex and significant issues addressed in this exhibition and within these pages. I can only say on behalf of each of the seminar participants, "thank you".

The initial project and this exhibit would not happen without the support of a number of generous benefactors. Walter and Darlene Hansen provided major support for both the seminar and for this exhibit. They have a keen interest in Christians engaging the arts and in building fellowship and partnership worldwide. They were delighted with our earlier effort of this kind in Indonesia and they spurred us on to do it again. The Hansens were joined in their underwriting by Doug and Lois Nagel, John and Mary Loeks, Joan Gilkison of the Gilkison Family Foundation, the Calvin Center for Christian Scholarship (CCCS) and the Lilly Fellows Program in the Humanities and the Arts. Each American artist on the team also received support from his or her home college or university. Professor Susan Felch of the CCCS and Professor Joe Creech of the Lilly Fellows Program have been great encouragers and supporters of this project. Professor Creech was instrumental in securing our invitation to open the exhibit at the annual national conference of the Lilly Fellows Program in Humanities and the Arts, held at Xavier University in New Orleans on September 26-28, 2014, in New Orleans.

Finally, there are no words that can express the investment of the artists without which there would be no exhibit. Many of them worked long hours beyond producing their stunning artworks to

help solve myriad problems or provide information essential to the success of this enterprise. I hope they know how grateful I am for their selfless investment. I am personally indebted to Nicholas Kerton-Johnson at my home institution, Taylor University, for his encouragement and help in setting up my first visit to South Africa and to Karen von Veh, art historian at University of Johannesburg who following a brief but providential meeting at a conference of the Association of Scholars of Christianity in the History of Art (ASCHA) in Paris in May 2010 opened my eyes to the incomparable vitality of the art of South Africa and opened doors to the arts and academic communities there by making introductions that established relationships without which this project could not have been possible. Thank you.

My sincerest hope is that *Between the Shadow & the Light* will enrich you as much as it has me.

—*Rachel Hostetter Smith*, Curator and Project Director
Between the Shadow & the Light
Gilkison Professor of Art History at Taylor University

Jonathan Anderson

continued from page 48

to the process of its own making through a particular set of actions in a particular location in Long Beach, CA.

The decision to make the painting in this way grew out of at least two sensitivities that have remained with me since my time in South Africa: (1) Any representation of a place that is as densely meaningful (and contested) as Cape Town is always a view from somewhere. I am intensely aware that my experience of that place, my studies of its history, and my subsequent attempts to represent it in thought, word, and image are always only intelligible to me from within my own particular social conditioning. (2) Both in South Africa and upon my return home, I was struck by the significant similarities between Cape Town and Los Angeles, not only in terms of their climates and seaside geographies but also in terms of the social and economic divisions that demarcate their landscapes. Though the two places have very different histories and reasons for these divisions (I am certainly not equating twentieth-century Los Angeles city planning with apartheid), I am sensitive to the ways that a sober understanding of the problems and dysfunctions that continue to riddle post-apartheid Cape Town keeps impinging upon my understanding of the exceedingly different socioeconomic pockets within the greater Los Angeles area. I can't hold my representations of South African society off as simply wholly "other" than those surrounding my studio.

Memorial

This work references the various piles of rocks that function as memorials of the anti-apartheid struggle in South Africa, particularly the pile begun by Nelson Mandela in the quarry on Robben Island. The pile presented in this work is comprised of stones, broken masonry, and asphalt taken from South Africa; they are broken pieces of a place which evoke long histories in which such objects were thrown in acts of resistance. Presenting them in a pile such as this signifies a laying down of what was once taken up in violent resistance—a laying down as both an act of remembrance and an act of peace. Here they appear on an ornate (and fairly old) European lace tablecloth: the laying down of stones is received by (and necessitates) some kind of corresponding forfeiture of privilege. This is meant to capture something of the tension (and costs) involved in post-apartheid reconciliation.

Property Lines

This work is a procedure-generated sculpture that takes a new form each time it is exhibited. The sculpture "begins" by placing a generic wooden white house structure somewhere on the floor of the gallery. The finish of this house is a matte paper white, and its footprint is equivalent to an A4 size sheet of paper: the standard size used for paperwork and official files in South Africa both during and after apartheid. Working outward from this location, single sheets of A4 paper are laid out on the ground, forming a gridded paper landscape of whatever size and shape is desired in the exhibition space. As this landscape approaches its final size, a second house form (which has been burned) is placed on the outer edge of the grid, and the final row of the paper grid is laid down on either side of it. This work is a response to the role of bureaucratic systems which determined where people could and could not live based on their racial designation.

Theresa Couture
continued from page 58

looks, yet only as if through an open doorway, only from well inside my eyes, where I can frame what is outside, checking it on all sides, curbing its vastness, until what I see is another world that is simply this world. I reach into it then; take out a chunk. It is sheer privilege learning the limits of immensity.

Duet

During the R5 seminar I showed this piece to the group as a work in progress, a study in light and shadow. At the time I had no inkling of how it would turn. I simply knew that it was not finished. About half way through the long journey back to New York at the close of the seminar, however, I suddenly knew what I wanted to do with it. Unable to successfully take a nap, I passed the time reflecting on the R5 experience as a unique demonstration of contrasts, many levels of contrast. Many dualities! Some were harsh—extreme poverty contrasted with adjacent affluence, for example. But as I kept thinking about the experience as a whole, I marveled at how many of the dualities were complementary, were compatible and unifying. Duets!—if one could realistically have them that way. And so I turned my study into what I hoped would become a subtle, yet dynamic interweaving not only of light and shadow, but also of motifs that in some instances clearly resemble one another, and in others merge through both difference and relatedness, always forming a harmonious whole. A delicately proportioned blossom, one person has remarked about the result. I see it more as the trace of an elegant dance It is connected to thoughts about form and content in art, about difference and hybridity, neocolonialism and globalism, memory and innovation, etc.—those ambivalent separations and sometimes controversial dichotomies which in my work do not show up in any blatant or political fashion, but which I think in some circuitous way do inform my search for convergence and reconciliation in both art and life.

Ubuntu (I am because of you) could perhaps be an appropriate subtitle for this piece. The word expresses a South African world-view of humanity, humility, and humanness. "The basic idea is that we live in an interdependent spiritual cycle and a value system that affirms our identities." (Glenn Ujebe Masokoane, Director, Cultural Development, Department of Arts Culture, South Africa)

Holy the Day
Morning Curtain: The Hour of Lauds (Morning Praise)
Evening Cavern: The Hour of Vespers (Evensong)

These two works, inspired by the psalmody of the Liturgy of Hours, also known as the Divine Office, highlight the two major hours, namely Morning Praise and Evensong. As a pair they celebrate the arrival of both light and darkness, that is, the splendor of the evolving day, the cadence of time repeatedly and continuously vibrant with a hope that is within our grasp. How special it was for me, early one morning, to join the Sisters in Constantia for Lauds and to additionally participate in Evensong at Archbishop Tutu's St. George's Cathedral!

Morning Curtain presents a kind of gossamer as it frames, then releases, the morning star and unfolds new light over a smooth, still, yet undefined landscape. Morning marks the most receptive time of day. Its arrival defines earth with shadow and raises a gentle light to unfurl the vastness in which we reside.

In faith we want the morning's curtain habit of pulling the earth, of drawing life itself, into the open 'every

morning all over again'. Metaphorically we know our own need to rise, to welcome anew the lavish, but almost silent call to live in the dying that the day will ask. There is a hint of ancient psalmody in Morning Curtain, a brief line of neumes suggesting that perhaps in inheriting layered meanings we too can dare to hope that 'all will be well'.

In contrast to the openness of *Morning Curtain, Evening Cavern* is a series of partial enclosures, monumental planes acting, perhaps, like a protective citadel, harboring the embers of a day's experience. Here surfaces are no longer smooth, but rough and worn. Here the landscape, earlier flat and continuous, has shifted to separate vertical walls that cascade and shrink to a cavern holding remnants of fire, water, and other things of the earth. And a medieval illuminated manuscript dominates the scene as it continues to spill its messages into the light. Instead of a diaphanous curtain disappearing and taking with it the morning star, here fugitive incense leads the eye beyond the caverned archive of the day toward the Sacred Book; the Book in turn spreads its pages before a distant opening that reveals, faintly, the evening star. With night falling, ablaze and jewel-like in celebration, we are again invited to rise, this time in praise and gratitude, to embrace the passing day, and to trust its pathways into the day to follow. *Holy the Day* comes from a consciousness—often challenged by a society given to skepticism—that in the rhythm of our earthly existence, light emerging from the darkness is more commensurate with the deeper meanings of reality than a dimmer view of darkness extinguishing the light could ever claim to be.

I have been thinking about extending this project to include the remaining six Liturgical Hours. In fact, I am already producing sketches. It has been particularly engaging to begin with Lauds and Vespers—which my religious community recites daily—as a way of discovering in the Divine Office a structure for visually reflecting on how we grow with the days that keep dawning and particularly how we become whole by means of freedom to live our lives "for ever taking leave" (Ranier Maria Rilke), forever abandoning ourselves to a richness that cannot be fully imagined.

The Liturgy of Hours has marked the daily rhythm of monastic community life since the Middle Ages. Out of that context it is one of those defining forms of Christian prayer that can communicate across continents and across time. The strength of its poetry, its music, and its ritual gestures has the capacity to evoke those depths of the inner being where human experience, pointing to other human experience, opens fresh dialogue with both ancient traditions and those yet to come. Indeed, the more we probe into any particular culture the more we find values that are truly universal there.

Deléne Human
continued from page 63

the past that have shaped us. In Zakes Mda's book *The Heart of Redness*, Mda refers to physical "hunger belts" used by the Xhosa people to distract or prevent them from feeling their hunger during the famine in their land when the English started to "take over". In my work, however, the belts refer to the hopes, dreams and aspirations of contemporary South Africa.

The different colours of the belts are a reference to South Africa being the Rainbow Nation because we have so many cultures, different people, and eleven official languages. Each member of the Rainbow Nation has his/her own culture, background, story and history. In order to function as a society, each member contributes something but also has to let go of something and make compromises. All of the belts belonged to my female family members, close friends, or myself. Each belt has its own story, history and sentimental value. It was hard to let go of some of my belts but letting go is actually important to the meaning of the work as it relates to the five Rs of the seminar.

The beading techniques used in the creation of this work are very traditional. The necklace has both traditional and modern African elements. The colours of the beads at the top are from the current national South African flag whereas the beads across the "body" of the work are in the colours of the old RSA flag. The brown and blue metallic colours around the shoulders and necklace, as well as a light green and red metallic base represent my Western roots and background, which is overgrown with "African-ness". At the back in the neck of the work, there is a beaded section which resembles a barcode.

Beading is traditionally a female occupation in Africa especially in black communities. During the seminar we learned that traditionally women would use the different colours in their beaded works to convey certain messages to their husbands, betrothed ones, family and friends. Using the colours of the South African flag, I am writing my own message of the hope, courage, and faith of our country and its people. When we visited the Johannesburg Art Gallery (JAG) we saw a room with fertility dolls and traditional African artifacts. This work is a creation of my own fertility doll representing the "fertility" of our country as well as to my identity as a South African white female in contemporary society where each individual has much to offer to the growth of this country.

Jackie Karuti
continued from page 65

many lemons and at the time of the bombing, I projected what I believed was right, into a deed impacting the lives of many innocent people, the community, my family and myself. I will only be able to comprehend the full impact on the day I will be able to face you in person. I so badly wanted to share in this day, but due to circumstances beyond my control, I can only voice my sincere remorse through someone else and know he will impart my apologies for not being able to be here in person. Fulfilling this desire will only be possible in God's perfect timing for my release. In prison I requested a Bible and timeously searched out the truth. The truth started to oxygenate my veins and awakened my zeal for a new beginning by opening my heart in 2006 to participate in programs such as Khulisa,

Mind Power and Restorative Justice. Embracing the truth of God's Word, as well as the genuine care of people, have contributed to my sincere remorse, crying out for forgiveness and accepting Jesus Christ as my Saviour in 2007. Soon thereafter a desire was born in my heart to personally meet the victims *whom I have wronged. This dream was fulfilled in 2009 when Olga Macingwane visited me in prison. I did not expect her to forgive me, but the love in her heart imparted grace and forgiveness which resulted in freedom beyond understanding.*

Valentine Mettle
continued from page 70

quest for justice. Through the struggle they sought peace, love, and humanity. Apartheid ushered in a period of repression infinitely worse than anything experienced before. Nelson Mandela, as a young activist with the ANC (African National Congress), began to change its direction to mass-based movement on liberation from apartheid in South Africa. Despite the great division it involved, often along color lines, the South African freedom struggle eventually resulted in human rights for all in 1994. The triptych specifically focuses on the struggle time to freedom or victory.

The first panel subtitled *Resistance* tells about the incarceration of Nelson Mandela during his fight for the freedom of the people of South Africa and Africa as a whole. Africa can be seen right in the middle of the world with the tight fisted hand of Mandela. The hands surrounding the globe indicate the support of the people of the world for the freedom of the people of South Africa. The thick blue lines across the canvas represent the iron bars on Mandela's prison window at Robben Island.

The second panel subtitled *Petition* shows how the church was also an instrument of support for peace and emancipation of the people of South Africa. Hands can be seen raised to God by adults and children seeking divine intervention.

The third panel subtitled *Release* shows the jubilation and time for reconciliation after all the struggles once freedom was achieved. South Africa became free and Africa is free at last, because Mandela was freed. If Mandela hadn't been freed, I wouldn't have been free to relocate to South Africa.

The hands in the work represent the expression of the heart. People raise their hands for many reasons: to reach out to God, to invite God to be present with them, to show gratitude, and to express joy. It is like a child lifting his or her hands to be picked up.

My experience for two weeks of the R5 seminar, visiting historical sites and other places gave birth to these works. I saw children as innocent as ever and happier than the adults because they never experienced or went through the struggles. But I also see these children bringing about a radical change so that Mandela's dream of a united South Africa and Africa will come to pass.

Magdel van Rooyen
continued from page 78

loss of things gone and changing, the loss of hope, versus hope that it might be for the better and that all will be well. I am so proud of our country! There are little bits of shining hope but it is a daily decision not to think about all that is not good, of that which used to be but which is now broken down and changed. Or that which was good, or has been built anew and is not appreciated or maintained. Living in fear of your belongings being taken or being hijacked, raped, or killed versus enjoying our beautiful country, visiting our lovely parks, or seeing how a big event like the 2010 Soccer World Cup can unite us.

The painting is done on rusted steel and some of the rust is still visible. I wanted to express the fragility of the situation and the threat of the rust taking over or invading the painting, destroying it. The tension between hope and loss.

Visual Diary: R5 Journal

This simply contains the drawings and notes that I kept during the two week journey. It gives one an idea of the principle themes and experiences. Some are personal and others are quotes from people or writings I encountered during the seminar.

Rusted Protea

Having been given the task of collecting found objects or "trash" to the studio workshop sessions, I noticed an appealing piece of wood on the beach over lunch one day. Later on, during the visit to the community at Kayamandi I saw how many rusted bottle caps there were lying around and also collected these. In the simple process of putting these materials together a rusted protea flower appeared, linking the materials to its surroundings on a literal and a contextual level.

Katherine Sullivan
continued from page 83

of the indigenous, majority African population, as the vital core and heart of the country.

Purple Shall Govern II, Interrupted Atman

This painting is a combination of things observed in South Africa during the R5 experience. It references the pile of rocks on Robben Island laid as a monument by Nelson Mandela and other freed political prisoners, the architecture of Freedom Park, and the patterned fabrics and beaded dolls of the Ndebele and Xhosa.

The red line that appears throughout the painting functions in three ways: first as flat "background" space for the vertical purple form; next, as margin or border defining the left side of the canvas, and finally,

as a linear motif that separates from the canvas's border and, thus "interrupted," binds together the disparate elements of the abstracted form. The flat red border is borrowed from the Pahari School of Indian miniature painting, where it often functioned, in concert with a flat yellow or orange background, to frame royal portraits or scenes of palace life. Here it functions to frame and bind together the forms that combine to govern a post-apartheid South Africa.

The dominant purple vertical form might be seen to reference the still-standing prison towers of the Old Fort Prison on Constitution Hill, now the site of South Africa's Constitutional Court. Its coloration and the painting's title are taken from a famous event that took

place in Cape Town in 1989. During one of the last anti-apartheid protests police sprayed protesters with purple dye from water cannons to disperse the crowd and to stain and more easily identify them for arrest. One protestor seized control of the water cannon and turned the spray onto police and the surrounding government buildings. Graffiti of the phrase "Purple Shall Govern" appeared throughout Cape Town the next day.

Jo-Ann VanReeuwyk
continued from page 86

Tyre

The Journey to Freedom is an inter-racial, inter-media, collaborative narrative project between media artists at the University of South Africa (UNISA) and a collective of embroiderers from South African townships that we were privileged to view during our trip to South Africa. It continues to press on my mind. I attribute my anxiety in trying to understand more about the apartheid years and the resilience of humankind to this particular artwork. It entails large embroidered artifacts displaying the personal stories of incidents that took place predominantly in the townships during apartheid. These poignant pieces of work produced in what I have mistakenly considered a benign but also a comforting and "home"ly craft— embroidery—have given me insight into the atrocities that occurred during that time. These included the horrific practice of "necklacing." This continues to haunt me.

Necklacing is a term used in South Africa and in other parts of the world to describe a practice inducing great suffering and death. People in South Africa were "punished" by having tyres (tires) filled with gasoline placed around their necks and lighting them. The victims were often people *suspected* of betraying the freedom fighters to the South African authorities. I knew of this practice (having read about the Irish troubles) but it did not really come home to me until I viewed these narratives. The practice calls to mind Christ's total suffering. There is such irony in the use of the word necklacing similar to a term many might be more familiar with, "crown of thorns."

Kimberly Vrudny
continued from page 88

witness to how sin permeates souls, relationships, and structures, such that things like apartheid law become institutionalized, bringing harm to everyone it touches. It is this descent into broken relationships that is symbolized by the woman walking with her child in "Barcelona," a shack community outside of Cape Town. She survives, reflecting the image of God as all of God's human creatures are, but wounded, as we all are, by the atrocities that have been committed to protect the privileges of the few.

Panel 3: *Soteriology—Apartheid Museum, Johannesburg, South Africa* (bottom left)

"Father, forgive them, for they do not know what they are doing" (Luke 23:34). God has compassion for us, recognizing that we cannot save ourselves from the

damage that has been done. Jesus comes into the world to save the world by demonstrating a mind and will that is continually attentive to what is right and just, restoring broken relationships by embracing those who are marginalized and cast out, including lepers, widows, orphans, children, prostitutes, and tax collectors (each with an analogue to our own day), and resisting structures of political violence by challenging a religious system that has grown rigid and a governmental system that has brutally occupied the land of his people. Ultimately, the powers conspire against him, and he, like the political resisters in South Africa, was arrested and tortured. This was not something that God allowed, for God was present, too, calling for people, in their freedom, to enact what was good, to enliven what was beautiful, and to speak truth to power. God refused, however, to abuse God's power. God did not abuse God's power. God did not use force to stop the people who were killing the incarnation of Beauty to end their violence. Forgiveness was not forestalled, however, until Jesus was dead. He forgave his torturers from the cross, even as he welcomed a fellow revolutionary into Paradise. Like Stephen Biko and thousands of other South African martyrs, in addition to those who have worked for justice elsewhere, Jesus was killed. The nooses that hang now in the apartheid museum commemorate these deaths, separated by time but not by motivation.

Panel 4: *Pneumatology—Poster with Archbishop Desmond Tutu Crying During TRC, Cape Town, South Africa* (bottom right)

"[L]et justice roll on like a river, righteousness like a never-failing stream" (Amos 5:24). When the political forces that were opposed to justice, compassion, and wisdom killed Jesus, God, the One who is True, Good, and Beautiful, would not allow the forces of evil—injustice, indifference, and ignorance—to have the final say. This story is different from others like it, when sin, death, and the power of evil silence the prophetic voices of Martin Luther King, Jr., Oscar Romero, and other such figures. This story goes on to testify that, three days later, he appeared to his disciples, and they proclaimed his resurrection. Eventually, he sent his promised Advocate to be an everlasting presence among God's people, empowering humankind to enact what is just, compassionate, and wise; encouraging people, by grace, to become his hands and feet. Indeed, to live as he lived requires courage. We who become his disciples live into the resurrection, enlivening the body of Christ by living as he lived: committed to lives of justice and to peace. This involves not only personal righteousness in lives of devotion and prayer, but also resistance to religious and political powers that exploit and oppress. By listening to the voices of the prophets, like Archbishop Desmond Tutu, and by resisting powers of injustice, deformity, and deception—including the apartheid system in South Africa and other wicked ideologies propounded elsewhere—individual souls, damaged relationships, and oppressive structures can be sanctified. This is signified by Jillian Edelstein's photograph from the Truth and Reconciliation Commission, where Desmond Tutu cries, as Jeremiah cried, over his people. Mine is a photograph of hers, taken from a poster that was hanging as we boarded the ferry to Robben Island, and it is used with her permission. The prophets tell us that structures can be reimagined. They can be transformed. They can be made holy. Participating in this sanctification of the world is inherently a part of being a disciple of Christ.

Panel 5: *Eschatology—Kirstenbosch Gardens, Cape Town, South Africa* (center front)

"He will wipe every tear from their eyes. There will be no more death or mourning or crying or pain, for the old order of things has passed away" (Revelation 21:4). The Newer Testament is filled with vineyard imagery. The vineyard will be repeatedly ripped from the unjust and given to the just, Jesus taught; those who respond to the call and who work for justice are laborers in the vineyard, he promised; Gentiles are grafted into the Jewish vine, Paul commented. We are one race—Jew and Gentile, black and white, female and male, poor and rich. When we participate in the life that Jesus demonstrated, fixed on what is Good, Beautiful, and True—Just, Compassionate, and Wise—the vineyard comes into being, and all benefit from its sweet fruit and choice wine. Represented in the photography by the flower blooming in winter at Kirstenbosch gardens, the vineyard is coming into being in our midst, in the thin community of humanitarians and justice seekers who live simply, engage compassionately, and cooperate gracefully, attentive to those who are harmed by the systems as they stand. This is the way of people like Nelson Mandela, who sacrificed so much so that the dignity of South Africans, no matter the color of their skin, would be acknowledged and valued. Ultimately, this community's vines of justice, compassion, and wisdom will spread to all the world, so there will be no boundary between those who are inside, and who are outside. Heaven will return to earth, reunited with a restored Eden, a new Jerusalem, a society of peace and loving-kindness, of *shalom* and *hesed*. This is our destiny. This is our hope.

The kingdom of God is like a vineyard, Jesus said . . .

A Brief Timeline of South African History

	Evidence that humans lived and hunted in South Africa some 110,000 years ago
	San rock art dating back to 28,000 BC
c. 300	Migrants from the north settle, joining the San and Khoikhoi people
c. 500	Bantu people reach Kwazulu-Natal
c. 700	Evidence of trade with Arabs and Phoenicians
1480s	Portuguese explorer Bartholomew Diaz reaches Cape of Good Hope
1497	Vasco da Gama rounds the Cape
1652	Jan van Riebeeck, representing Dutch East India Company, founds the Cape Colony at Table Bay
1658	First slaves arrive from East Africa, Madagascar, East Indies
1770s	Europeans make contact with Xhosas at Fish River
1795	British forces seize Cape Colony from the Netherlands
1816-1826	Shaka Zulu founds and expands the Zulu empire
1833	Abolition of slavery by the British in the Cape Colony
1835-40	The Great Trek by the Boers founding the Orange Free State and Transvaal
15 December 1838	Boers defeat Zulus at Battle of Blood River
1852-54	British recognize independence of the Orange Free State and Transvaal
1860-1911	Arrival of labourers and traders from India
1869	Diamonds discovered at Kimberley
1879	British defeat the Zulus in Natal
1880-1	First Anglo-Boer War with Boer victory
mid-1880	Gold rush in Transvaal
1899-1902	Second Anglo-Boer War with British victory
1910	Formation of the Union of South Africa under British rule
1912	Founding of what will become the African National Congress (ANC)
1913	Land Act limits purchase of land by blacks
1913	Gandhi's arrest from his campaign against the passbooks for Indians and taxes
1934	Hertzog and Smuts form the United South African National Party; Malan breaks away to form the National Party
1943-4	ANC Youth League forms with Nelson Mandela elected secretary
1948	Policy of apartheid adopted by the National Party
1950	Group Areas Act to segregate black and white people; ANC initiates civil disobedience led by Mandela
1958	Henrik Verwoerd became Prime Minister
21 March 1960	Sharpeville Massacre—69 killed; ANC declared illegal

South Africa

Area – 471,000 sq. mi. or 1,219,000 sq.km. (approx. twice the size of Texas or a little larger than Italy, Germany, and France combined)

Population according to 2011 census data: 51.77 million; African 79.2%, Coloured 8.9%, White 8.9%, Indian/Asian 2.5%, Other .5%

11 official languages as of 1997: isiXhosa, isiZulu, isiNdebele, Sesotho, Setswana, Sesotho sa Leboa, Tshivenda, Xitsonga, siSwati, Afrikaans, English

9 provinces: Eastern Cape, Northern Cape, Free State, Gauteng, Kwazulu-Natal, Mpumalanga, North West, Limpopo

1961	Umkhonto we Sizwe (MK) (Spear of the Nation) formed, paramilitary wing of the ANC
1961	South Africa leaves British Commonwealth of Nations, becomes Republic of South Africa
1963-64	Rivonia Trial: Mandela sentenced to life imprisonment on Robben Island
1966	Verwoerd assassinated
1968	Stephen Biko is co-founder of the South African Students' Organization
1970s-1980s	Escalating civil unrest, sanctions imposed on South Africa, Forced resettlement process and Township revolts
1970	Bantu Homelands Citizenship Act strips blacks of their citizenship
16 June 1976	Soweto Uprising: students protesting schooling in Afrikaans Shot by police followed by months of riots
1977	Violent death of Stephen Biko, leader of the Black Consciousness Movement
1984	Archbishop Desmond Tutu awarded Nobel Peace Prize
1986-89	U.S. joins international sanctions against South Africa
1989	F.W. de Klerk elected President; announces unconditional release of Mandela
11 February 1990	Mandela released from prison
1990	ANC and government agree to negotiate a new constitution, repeal of the Separate Amenities Act, ANC agrees to suspend its "armed struggle"
1 February 1991	de Klerk announces repeal of the Land Act, Group Areas Act, and Population Registration Act
17 March 1993	White South Africans in a referendum endorse a plan to abolish the apartheid policies
1993	Mandela and de Klerk jointly awarded the Nobel Peace Prize
April 1994	ANC wins first open election; Mandela declared President of South Africa
1996	Truth and Reconciliation Commission chaired by Archbishop Desmond Tutu
1999	Thabo Mbeki inaugurated as second President
2009	Jacob Zuma elected third President; re-elected in 2014
2010	South Africa hosts the World Cup in Soccer

*—compiled from material from Professor Alan Winquist, Ph.D., History Department
at Taylor University, www.bbc.com/news/world-africa-14094918
and www.sahistory.org.za/timelines*

the Apartheid Museum in Johannesburg

South Africa is a country in which one can expect the unexpected. An inspiration for all. What made it possible was the determination of the people of South Africa to work together ... to transform bitter experiences into the binding glue of a rainbow nation.
—Kofi Annan, former Secretary General, United Nations

Excerpted from an address by Professor H. Russel Botman,
Rector and Vice-Chancellor, Stellenbosch University at a conference:
Laying Ghosts to Rest for an Audacity of Hope
17 September 2009

It is not my intention to dwell on the past, but I think it is imperative to acknowledge (in the words of historians) that we can only build a future on our past; we can only move forward if we know where we came from. The problem is, however, that our past is not an open book lending itself to a roadmap for the future....

I use the word "build" because working on social cohesion is like building a house. To build a house you first dig into the soil. Then you realize that in the imperfect trench you need to lay a foundation.... At best we are thus trying to build a new South Africa on the imperfect truth and an incomplete picture of our past. It is not the best of trenches to work from in building unity and one nationhood....

Working on social cohesion requires a much more perfect and solid foundation. Fortunately we have that in our liberal and progressive Constitution and our Bill of Rights. It reminds us that no right is absolute, no freedom limitless, and that we can only live our rights if we allow others exactly the same rights, freedom and privileges that we claim for ourselves....

We have made the imperfect trenches, laid the solid foundation of our Constitution and Bill of Rights. We have now proceeded to build the house, but somehow, the house lacks character. The walls are bare and the rooms display an atmosphere of harshness and despair. What is missing is the warmth of shared values....

But in line with my metaphor, every house needs a roof. And this is provided by the confidence in our institutions.... Although the roof completes the house, it does not yet make it a home! Social cohesion turns the house into a home. Social cohesion is thus the glue that binds the people so that all of them would call the same place home. Home is where they share warmth, love, calamities, challenges, loss and laughter....

Our challenge...is...[to strengthen] the glue that binds us together as a family and makes this house a home for all of us—a home with character.

—H. Russel Botman

Rector and Vice-Chancellor, Stellenbosch University
born 18 October 1953, died 28 June 2014
Professor Botman established the HOPE Project
at Stellenbosch University

Our perception of the world changes, not by the past itself but by the way we remember the past

Dreaming art, creating future

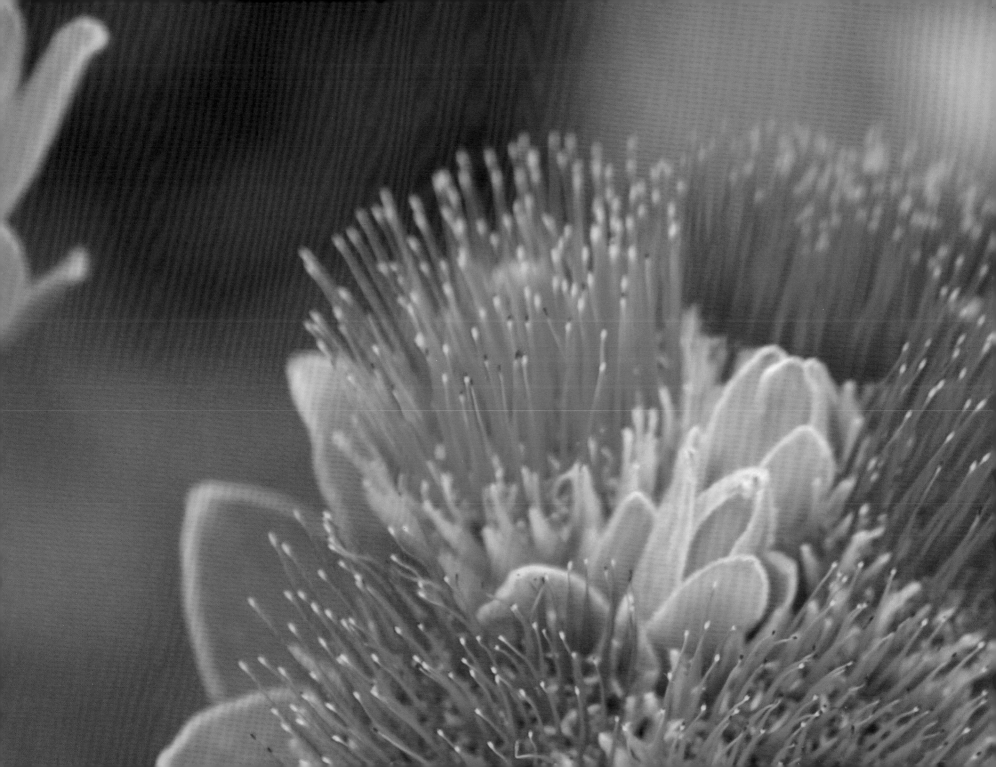

R6&7

Restoration & Renewal:

walking into the new heaven and new earth that is coming into being

*Groot Constantia in winter, the oldest vineyards
in South Africa, dating to the late 1600s*

"Our shadows were on the grass. They got to the trees before we did. Mine got there first. Then we got there. And then the shadows were gone."

—William Faulkner, *The Sound and the Fury* (1929)

"The question is not what am I to do but who am I called to love?"

—Johan Horn, Executive Head, (ALICT)

Then I saw a new heaven and a new earth, for the first heaven and the first earth had passed away,
and there was no longer any sea. I saw the Holy City, the new Jerusalem, coming down out of heaven from God,
prepared as a bride beautifully dressed for her husband. And I heard a loud voice from the throne saying,
"Now the dwelling of God is with men, and he will live with them. They will be his peoples,
and God himself will be with them and be their God. He will wipe every tear from their eyes.
There will be no more death or mourning or crying or pain, for the old order of things has passed away.
He who was seated on the throne said, "I am making everything new!"
Then he said, "Write this down for these words are trustworthy and true."

—Revelation 21: 1-5

For a world that
we build, create,
paint together.